Strange & Frightful Yōkai Coloring

Strange & Frightful Yōkai Coloring

60 Captivating Images of Mysterious Creatures from Japanese Folklore

Illustrated by Davie Yakusaa

castle

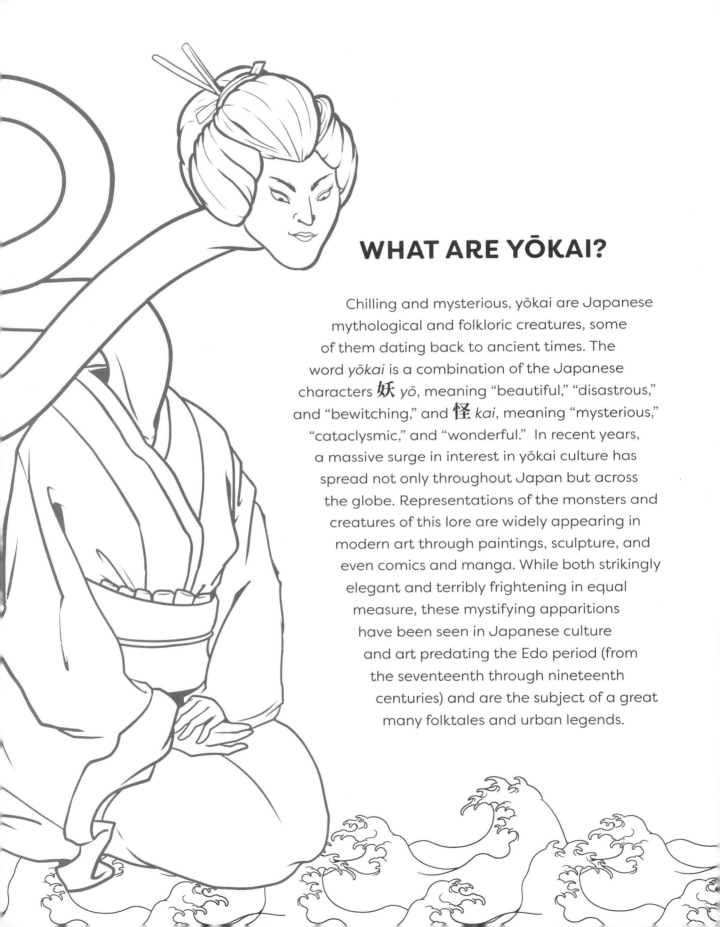

WHAT ARE YŌKAI?

Chilling and mysterious, yōkai are Japanese mythological and folkloric creatures, some of them dating back to ancient times. The word *yōkai* is a combination of the Japanese characters 妖 *yō*, meaning "beautiful," "disastrous," and "bewitching," and 怪 *kai*, meaning "mysterious," "cataclysmic," and "wonderful." In recent years, a massive surge in interest in yōkai culture has spread not only throughout Japan but across the globe. Representations of the monsters and creatures of this lore are widely appearing in modern art through paintings, sculpture, and even comics and manga. While both strikingly elegant and terribly frightening in equal measure, these mystifying apparitions have been seen in Japanese culture and art predating the Edo period (from the seventeenth through nineteenth centuries) and are the subject of a great many folktales and urban legends.

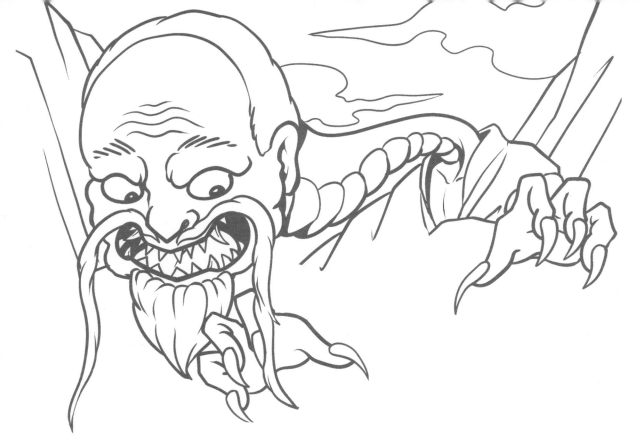

Much like the famed beasts of the Western world, such as Bigfoot or skin-walkers, yōkai are often intertwined with human lives and make appearances before unsuspecting people. Known to be mischievous, they can be either malevolent or benevolent to humans. With a large repertoire of supernatural abilities, these creatures are most commonly shapeshifters and can carry animal or human features.

For example, kappa are beasts who have some humanoid features, such as human arms and legs, but they primarily present as turtles with scaly green skin and often a shell. Along with taking the form of creatures, spirit-like yōkai monsters are said to inhabit all kinds of things, including places, everyday objects, and natural phenomena like spooky bumps in the night or a howling wind.

In ancient times, these specters were likely conceptualized to explain mysterious happenings not yet understood or to aid in human needs, such as expelling disease from a community. A fascinating and unique aspect of yōkai is that it is ever-evolving and old characters and myths have maneuvered their way into modern rhetoric. A good example of this is the amabie, an aquatic creature that resembles a mermaid or merman with a beak for a mouth and at least three tail fins. In the traditional tale, the amabie emerges from the sea to foretell a bountiful harvest or to warn of an impending epidemic. It instructs people to create likenesses of them through paintings, sketches, or other art mediums, and then give these to others in order to stave off widespread disease. If disease should occur, passing around pictures of an amabie is said to help keep it at bay. During the COVID-19 pandemic, Japanese social media users posted and spread images of amabie to ward off the illness, creating a global campaign with the hashtag #amabiechallenge. Additionally, the Japanese Ministry of Health, Labour and Welfare used images of amabie in their early initiatives against the coronavirus.

Far beyond being just a coloring book, this is a portal into the wonderful and fearsome world of the yōkai, where beasts rule and magic abounds. It is a bridge where the fantastical encounters the mundane, where the ancient meets the present, and where the supernatural greets the imagination.

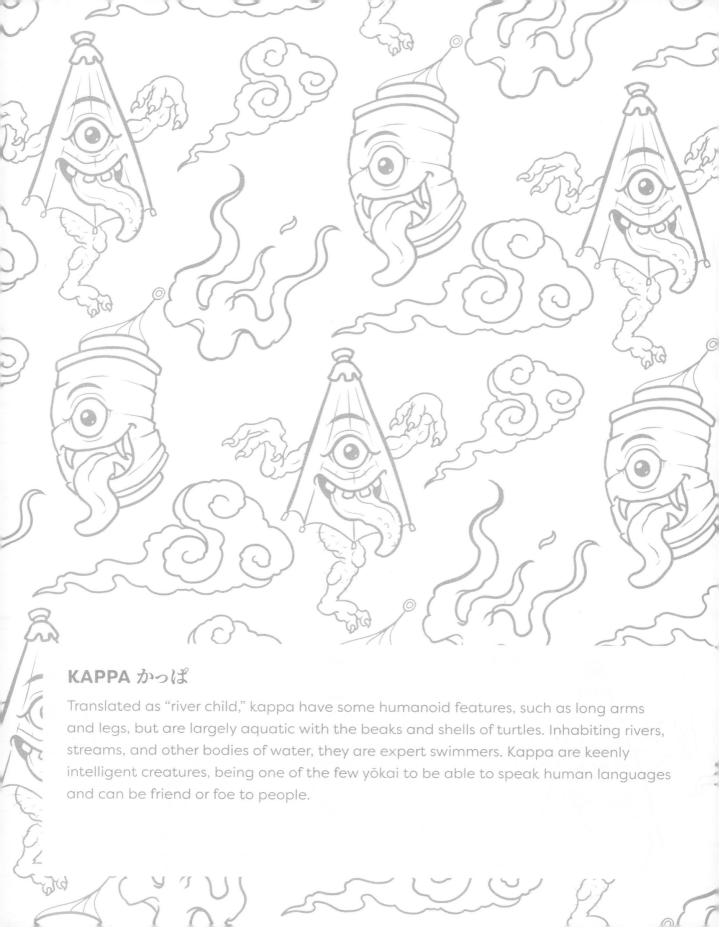

KAPPA かっぱ

Translated as "river child," kappa have some humanoid features, such as long arms and legs, but are largely aquatic with the beaks and shells of turtles. Inhabiting rivers, streams, and other bodies of water, they are expert swimmers. Kappa are keenly intelligent creatures, being one of the few yōkai to be able to speak human languages and can be friend or foe to people.

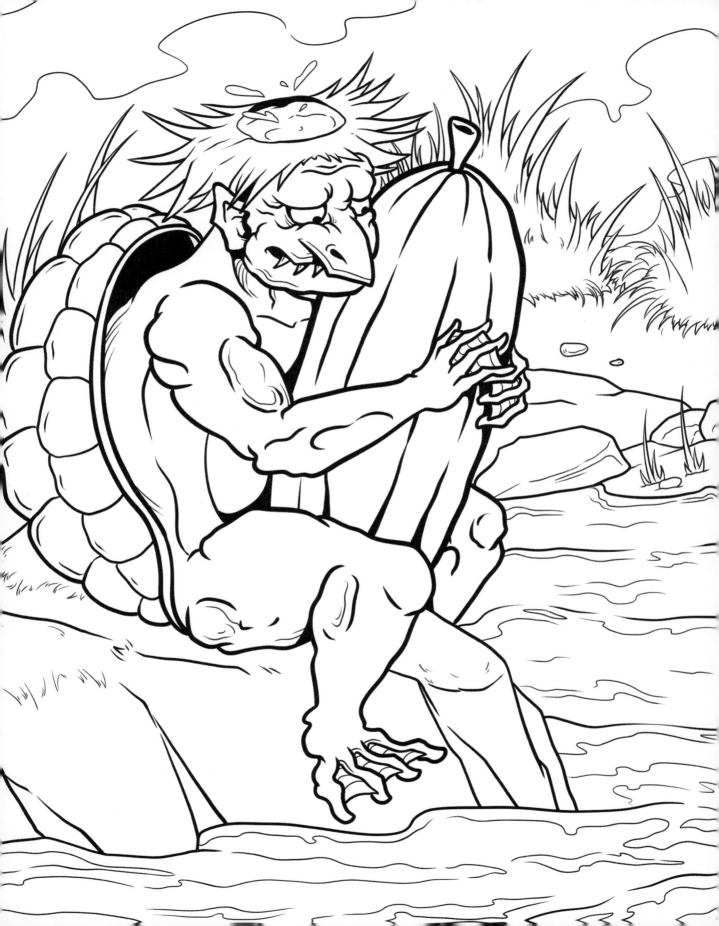

ONI おに

One of the supreme icons of Japanese folklore, the oni is a demonic ogre that brings disaster and disease. They stand taller than most trees and don wild hair and crazy eyes, two or more horns, and teeth-like tusks. They can be found on mountaintops and remote islands and in caves and in the underworld of hell. Much like the kappa, oni can be intelligent and are uniquely known as skilled sorcerers.

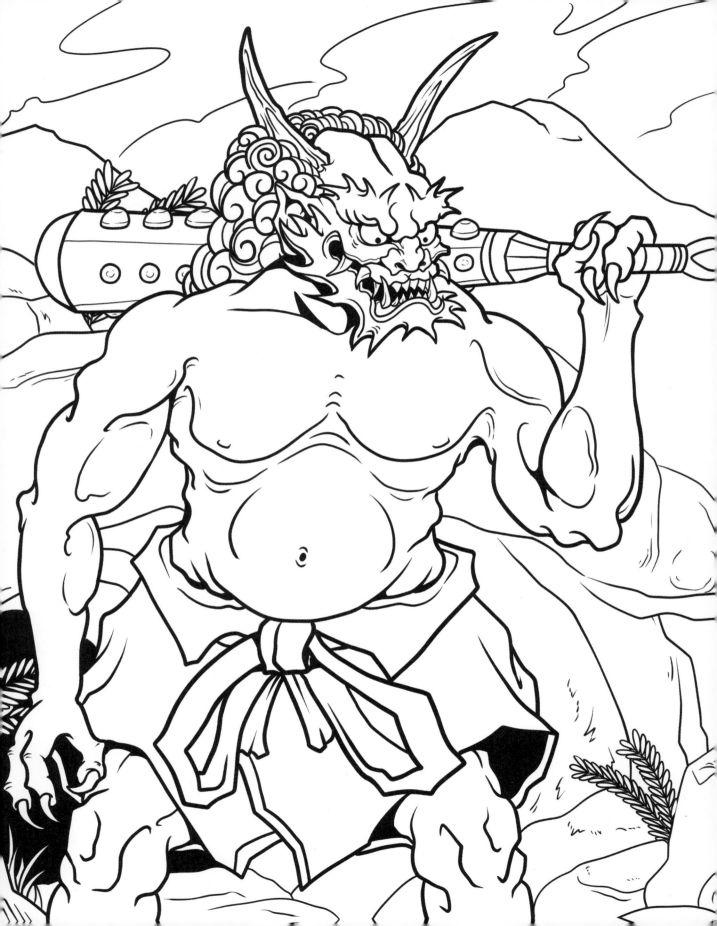

DAITENGU だいてんぐ

Sovereign among the various tengu, the daitengu are humanlike entities that wear the robe of a monk and have red faces with especially long noses: the longer the nose, the more powerful the spirit. They spend their lives in solitary meditation in pursuit of spiritual perfection. Natural disasters and massive calamities are often attributed to angry daitengu but the majority of the time they are kind and give aid to humans.

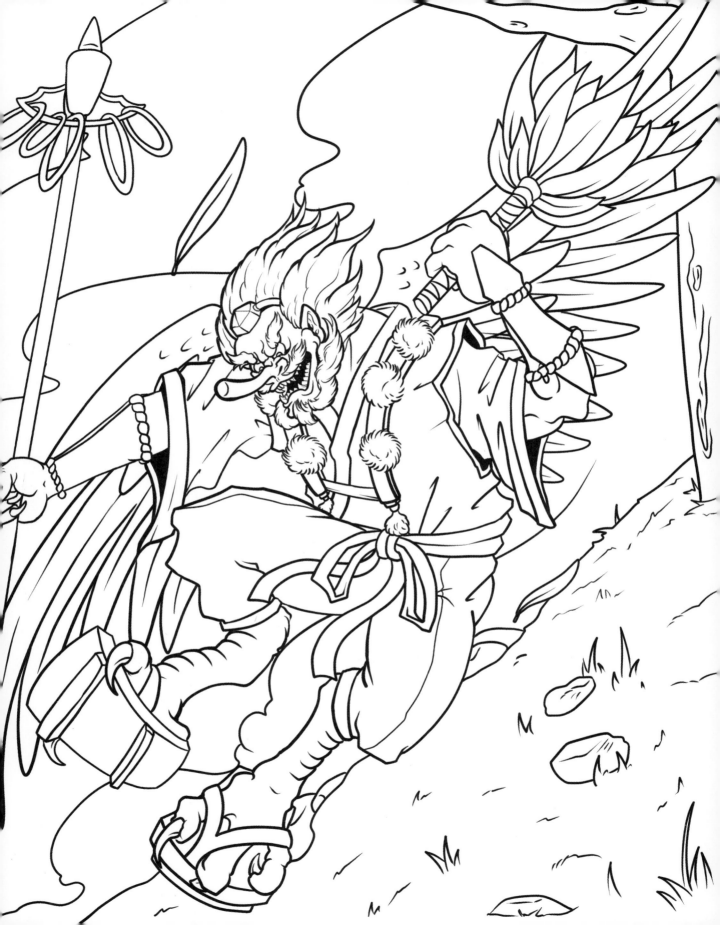

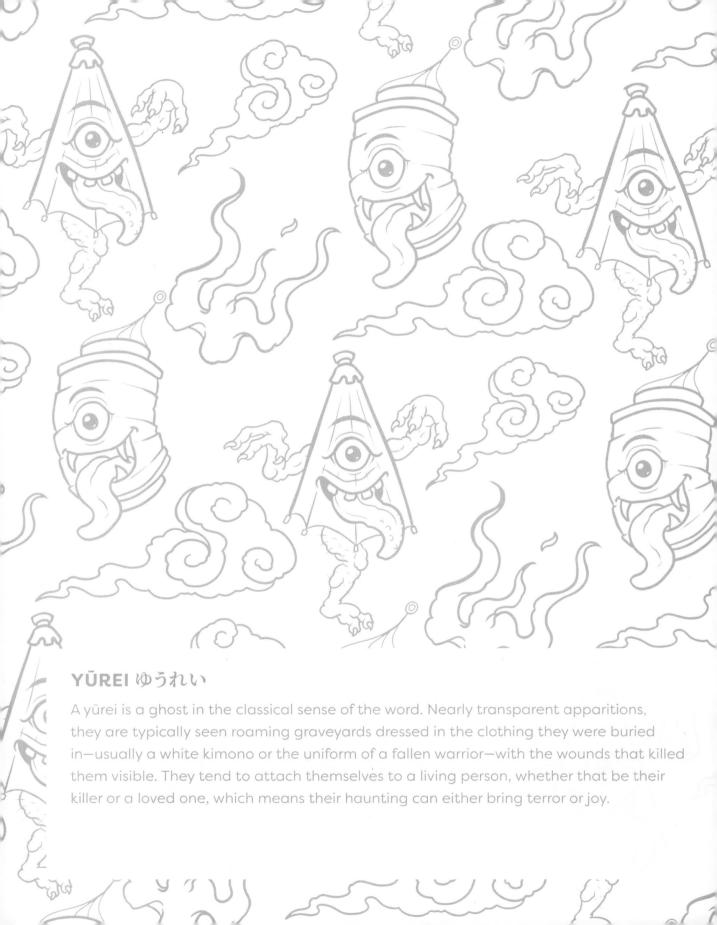

YŪREI ゆうれい

A yūrei is a ghost in the classical sense of the word. Nearly transparent apparitions, they are typically seen roaming graveyards dressed in the clothing they were buried in—usually a white kimono or the uniform of a fallen warrior—with the wounds that killed them visible. They tend to attach themselves to a living person, whether that be their killer or a loved one, which means their haunting can either bring terror or joy.

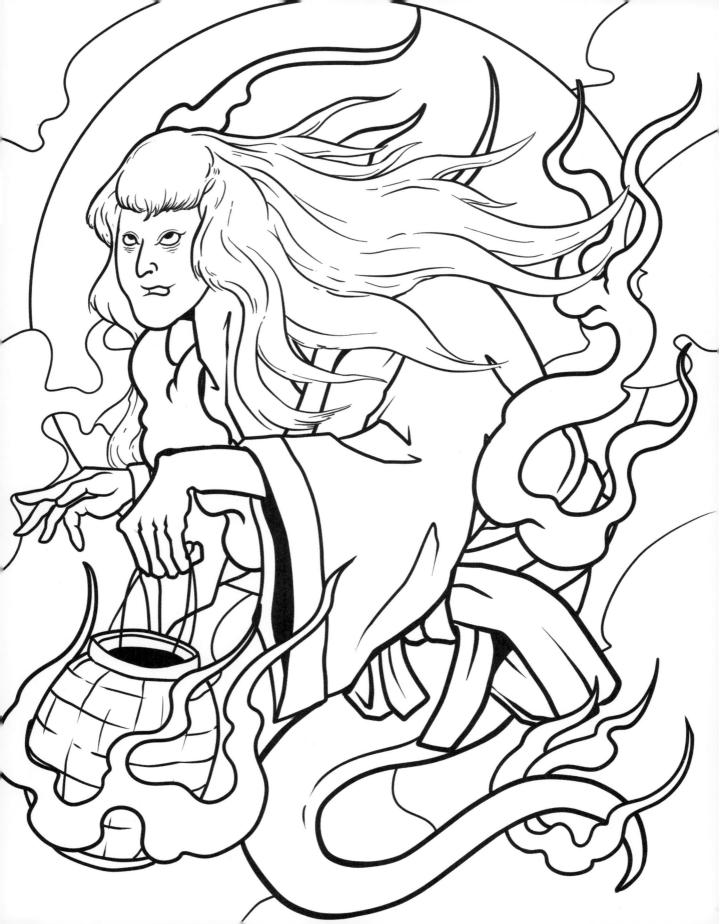

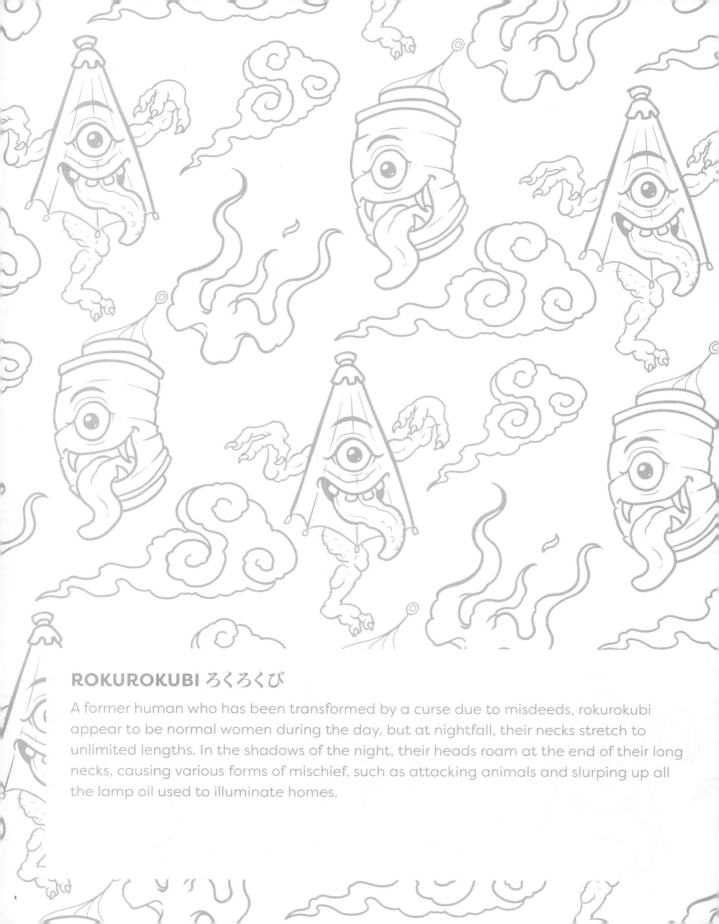

ROKUROKUBI ろくろくび

A former human who has been transformed by a curse due to misdeeds, rokurokubi appear to be normal women during the day, but at nightfall, their necks stretch to unlimited lengths. In the shadows of the night, their heads roam at the end of their long necks, causing various forms of mischief, such as attacking animals and slurping up all the lamp oil used to illuminate homes.

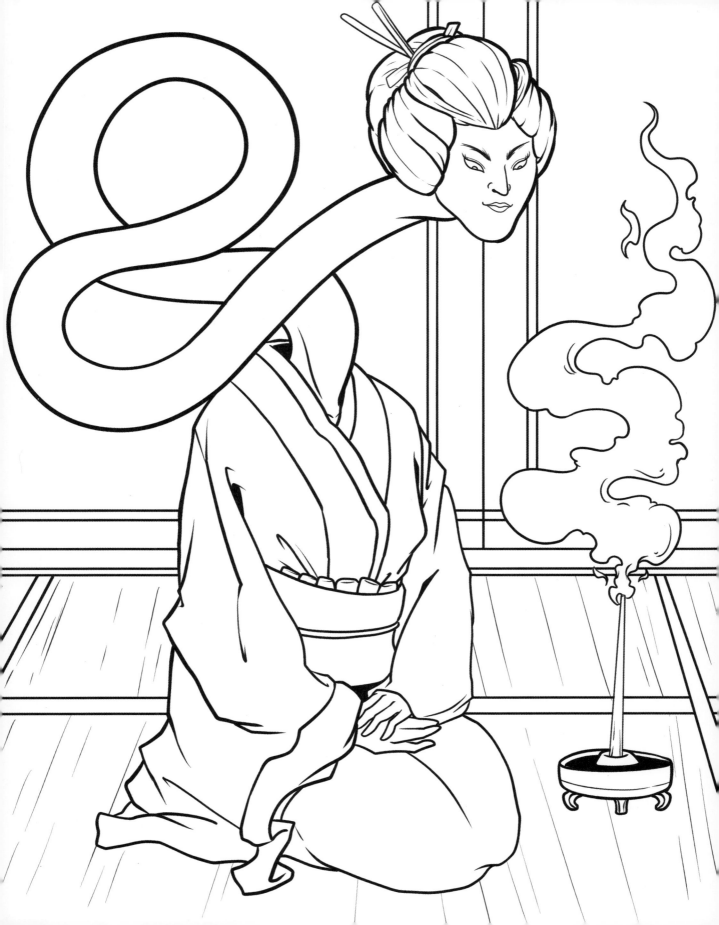

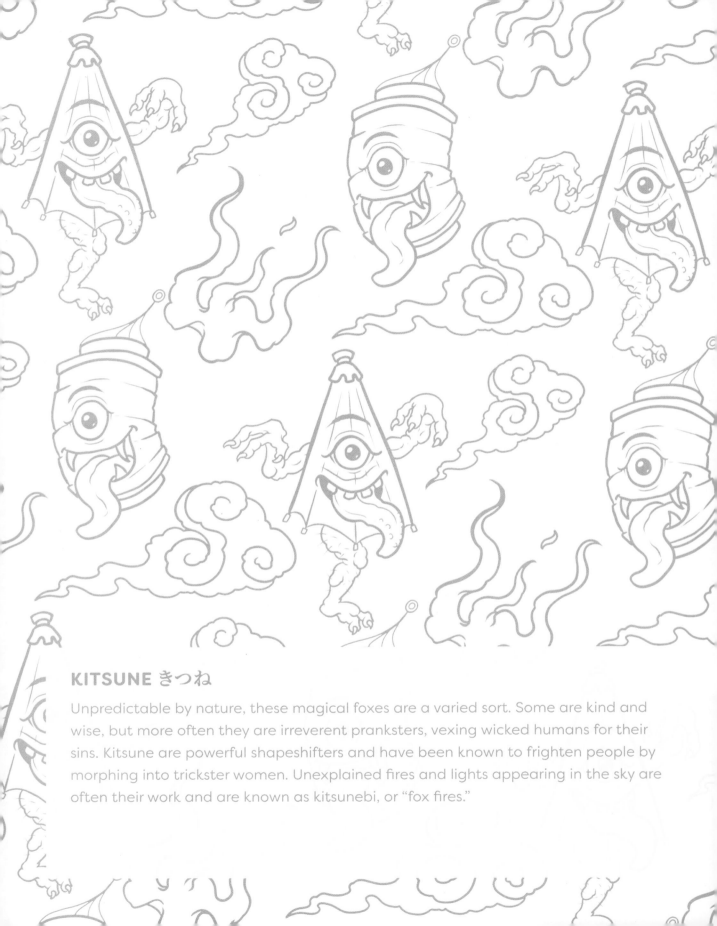

KITSUNE きつね

Unpredictable by nature, these magical foxes are a varied sort. Some are kind and wise, but more often they are irreverent pranksters, vexing wicked humans for their sins. Kitsune are powerful shapeshifters and have been known to frighten people by morphing into trickster women. Unexplained fires and lights appearing in the sky are often their work and are known as kitsunebi, or "fox fires."

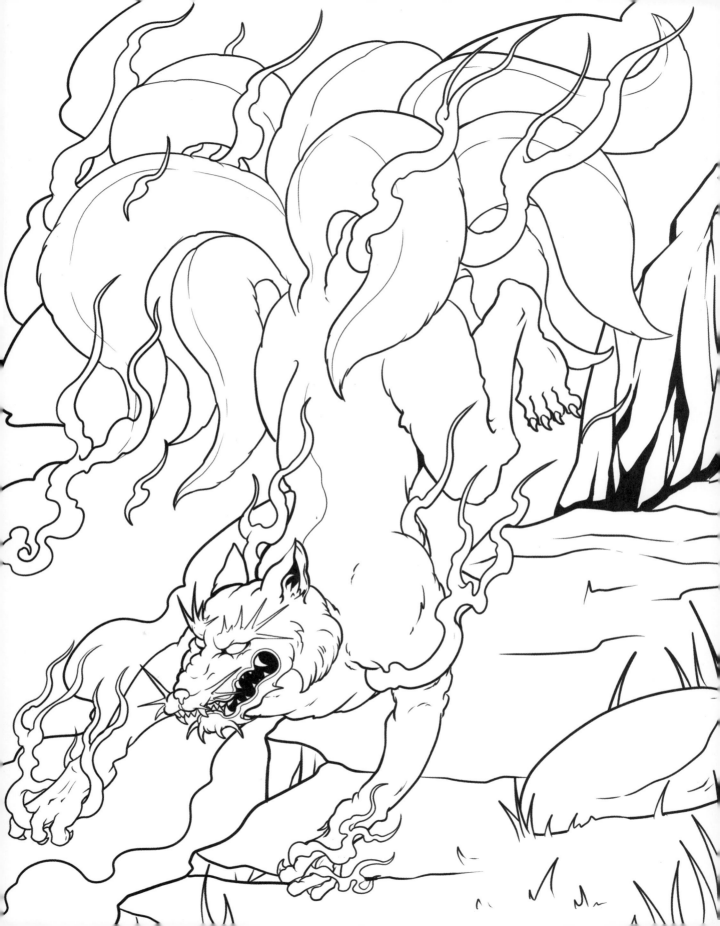

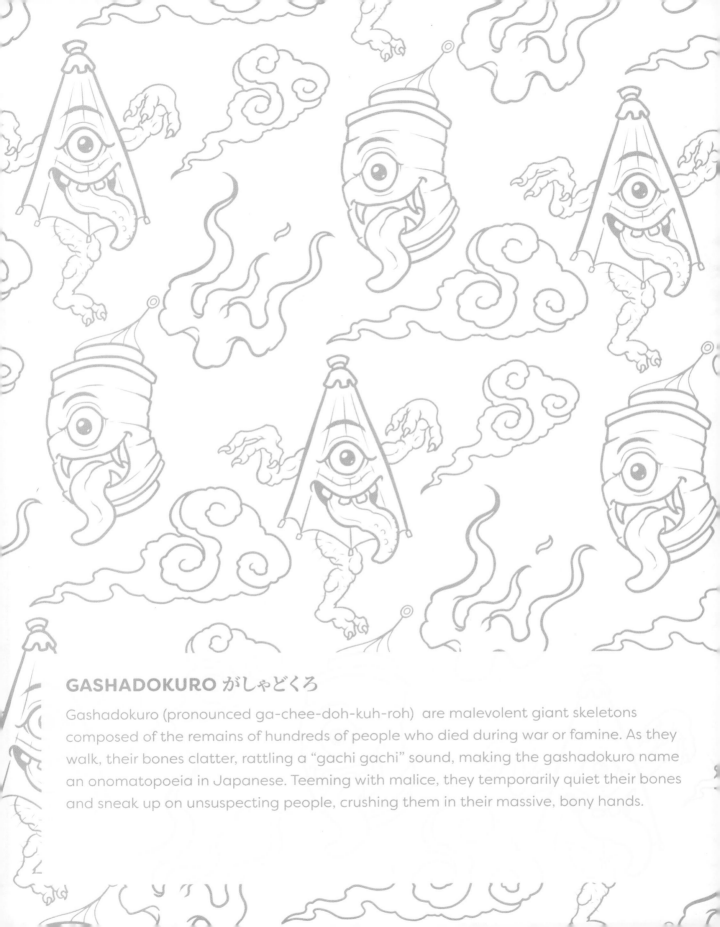

GASHADOKURO がしゃどくろ

Gashadokuro (pronounced ga-chee-doh-kuh-roh) are malevolent giant skeletons composed of the remains of hundreds of people who died during war or famine. As they walk, their bones clatter, rattling a "gachi gachi" sound, making the gashadokuro name an onomatopoeia in Japanese. Teeming with malice, they temporarily quiet their bones and sneak up on unsuspecting people, crushing them in their massive, bony hands.

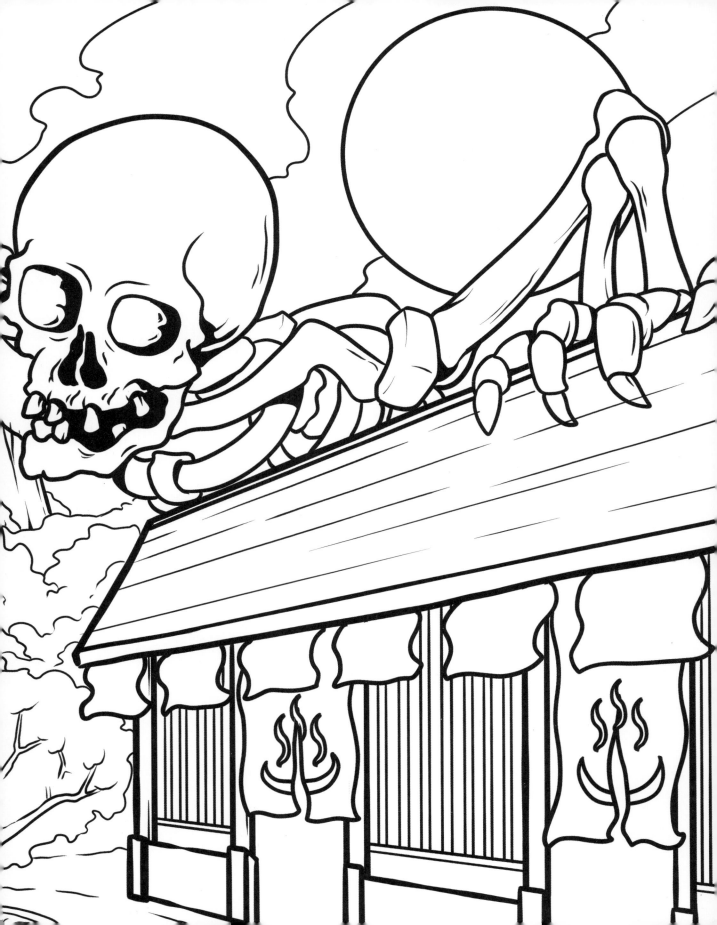

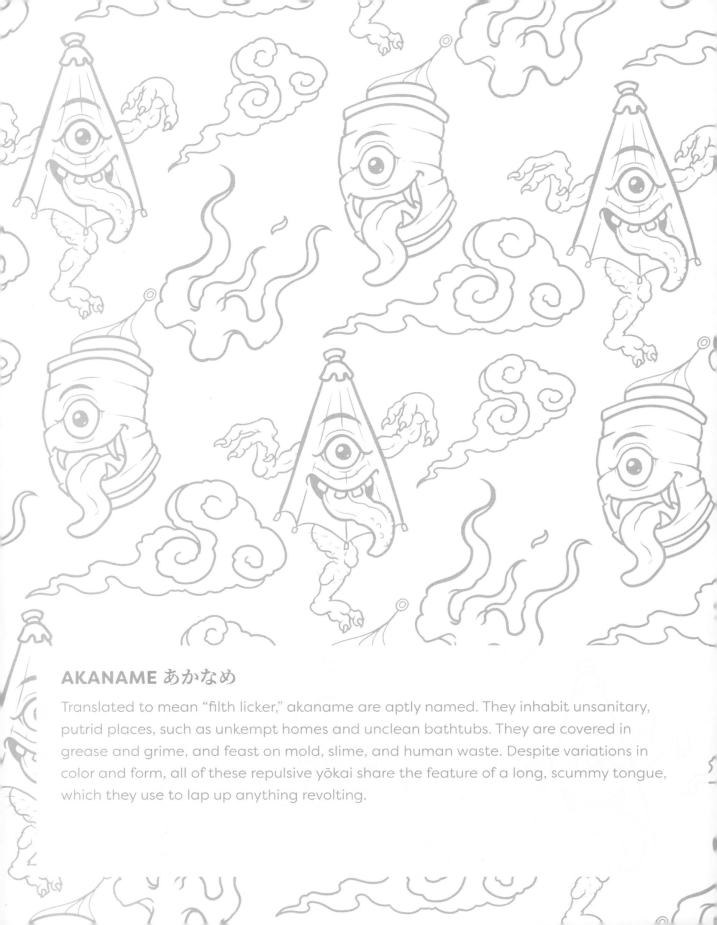

AKANAME あかなめ

Translated to mean "filth licker," akaname are aptly named. They inhabit unsanitary, putrid places, such as unkempt homes and unclean bathtubs. They are covered in grease and grime, and feast on mold, slime, and human waste. Despite variations in color and form, all of these repulsive yōkai share the feature of a long, scummy tongue, which they use to lap up anything revolting.

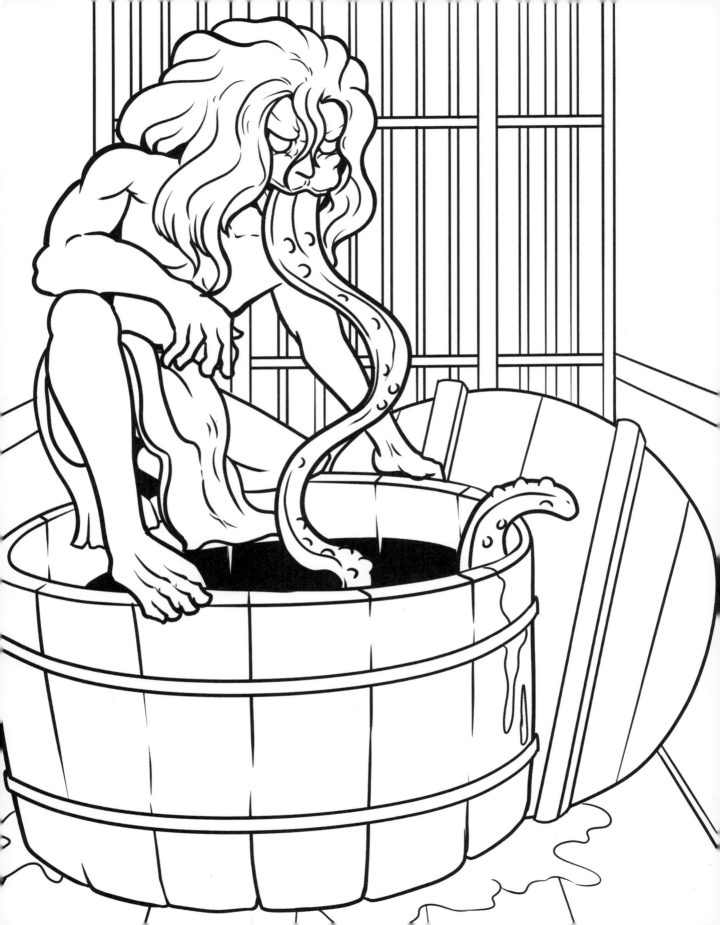

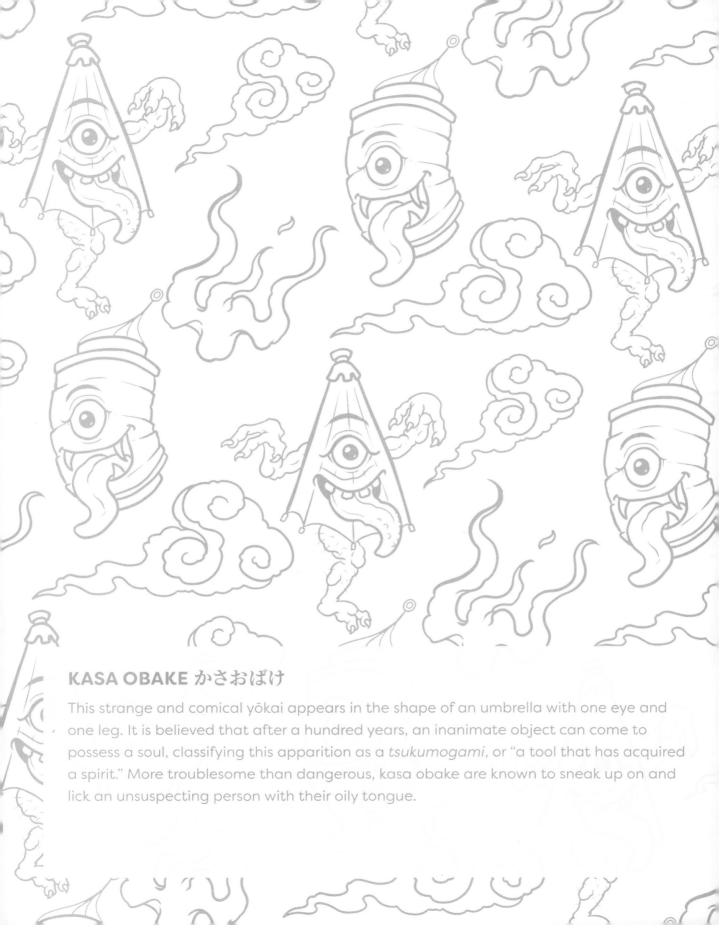

KASA OBAKE かさおばけ

This strange and comical yōkai appears in the shape of an umbrella with one eye and one leg. It is believed that after a hundred years, an inanimate object can come to possess a soul, classifying this apparition as a *tsukumogami*, or "a tool that has acquired a spirit." More troublesome than dangerous, kasa obake are known to sneak up on and lick an unsuspecting person with their oily tongue.

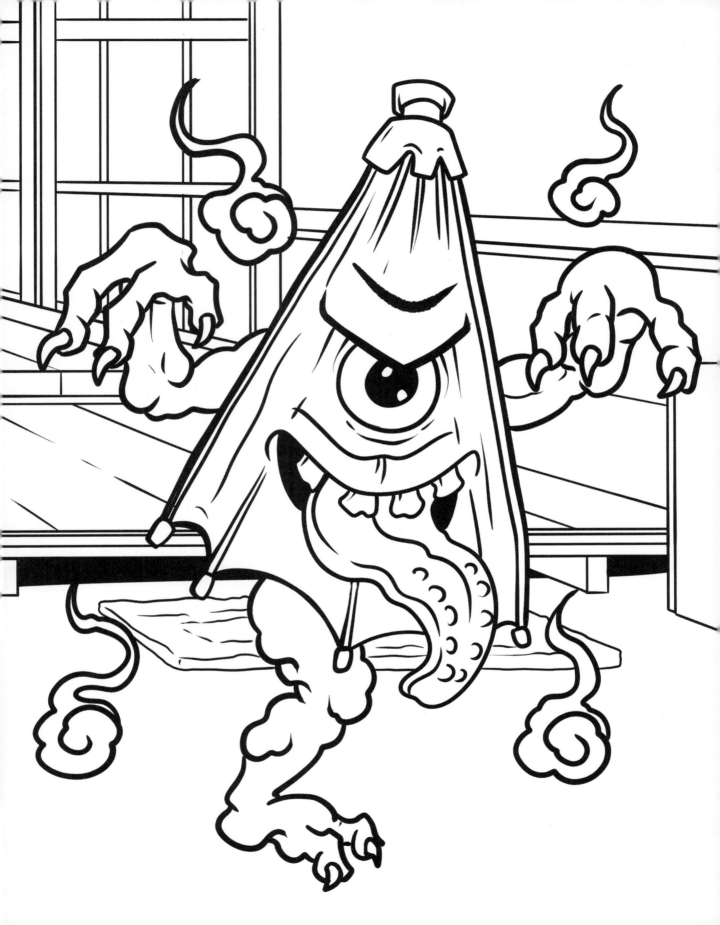

BAKENEKO ばけねこ

These ghoulish felines are not your typical house cats. Prolific shapeshifters, bakeneko can morph into human form, often that of their owner, and speak many languages. They can eat large prey, summon curses, and cause destructive house fires, with their tails acting as torches. A common feline can transform into this monster cat as their age ripens. An extra-long tail is a tell-*tail* sign they aren't to be trusted.

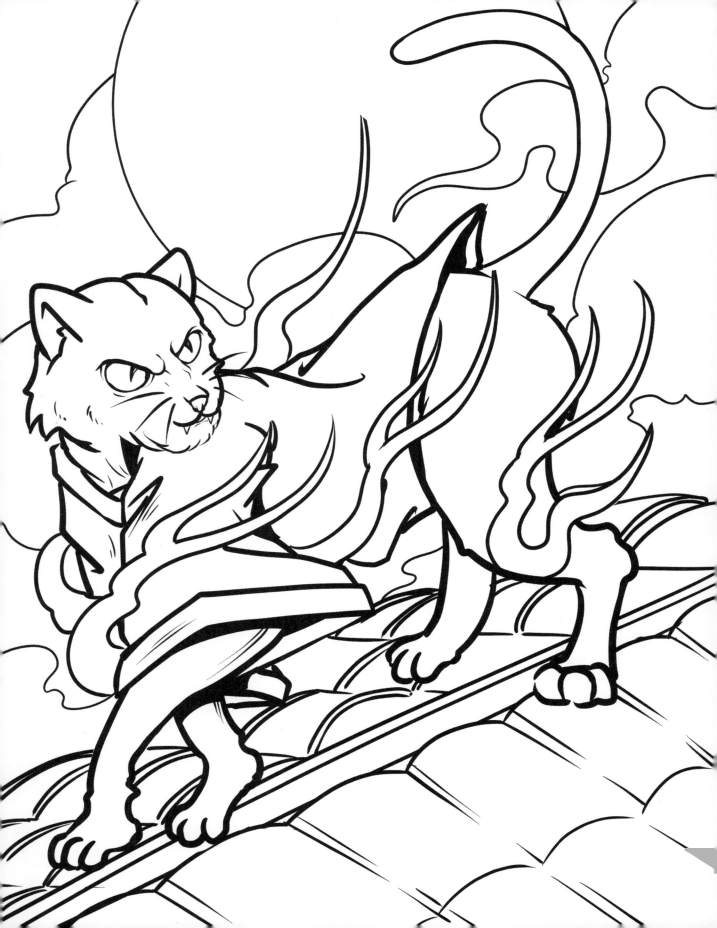

TANUKI たぬき

Considered by some to be the gods of nature, tanuki are highly powerful shapeshifters and magicians, and one of the most popular and widely beloved yōkai. The source of their power is their massive testicles, which they can manipulate into whatever they might need—from an umbrella in the rain to a fan in the heat, or even drums, fishing nets, and weapons. While they typically have good relationships with humans, there are tales told of vicious tanuki who devour people without remorse.

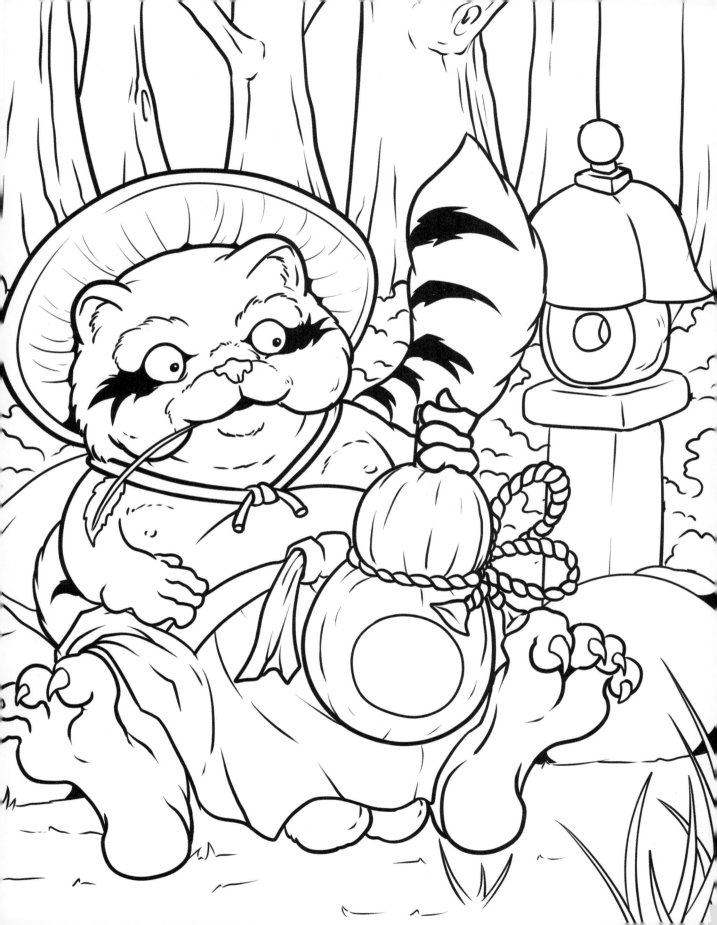

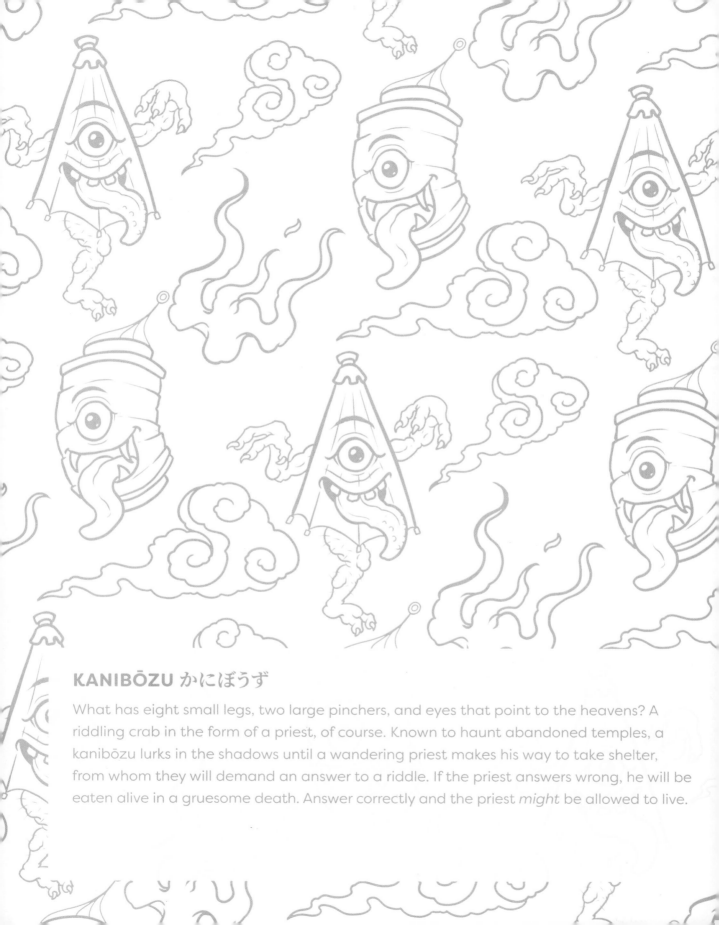

KANIBŌZU かにぼうず

What has eight small legs, two large pinchers, and eyes that point to the heavens? A riddling crab in the form of a priest, of course. Known to haunt abandoned temples, a kanibōzu lurks in the shadows until a wandering priest makes his way to take shelter, from whom they will demand an answer to a riddle. If the priest answers wrong, he will be eaten alive in a gruesome death. Answer correctly and the priest *might* be allowed to live.

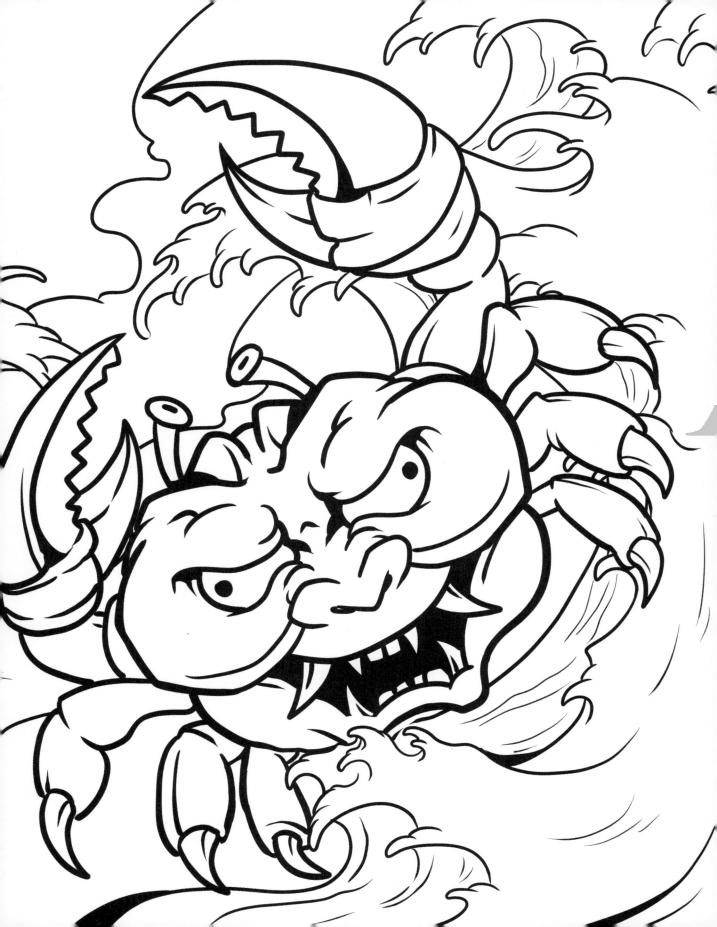

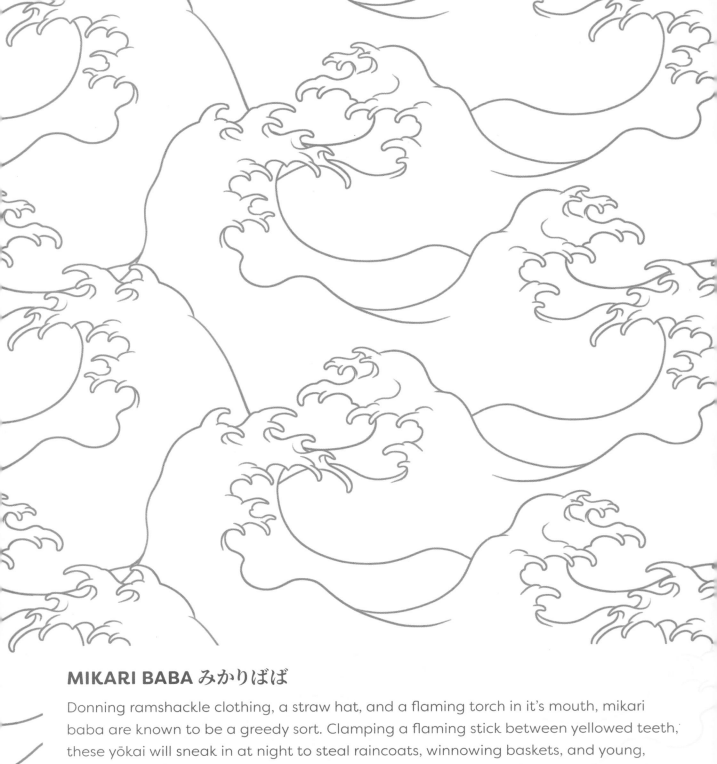

MIKARI BABA みかりばば

Donning ramshackle clothing, a straw hat, and a flaming torch in it's mouth, mikari baba are known to be a greedy sort. Clamping a flaming stick between yellowed teeth, these yōkai will sneak in at night to steal raincoats, winnowing baskets, and young, plump eyeballs from the living. Even a single stray grain of rice will attract these vultures, so keep your house clean and your coffers in order, and don't open the door to these harrowing hags.

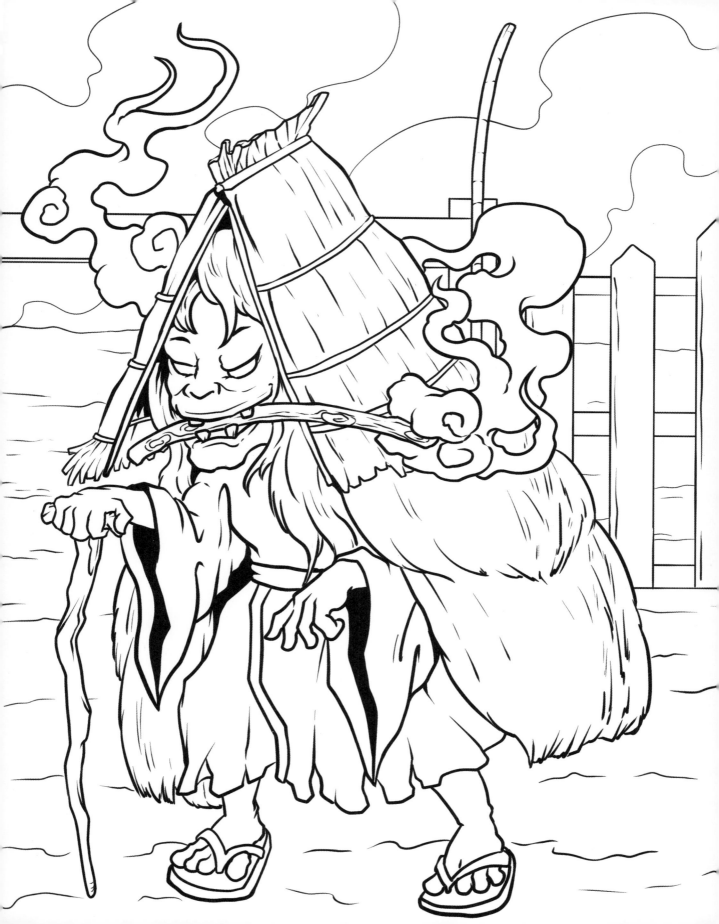

OTOROSHI おとろし

Haunting the shrine gates of Japan for centuries, otoroshi are blue-skinned, four-legged beasts covered in coarse hair and with large tusks. They protect the spaces that connect the earthly realm with that of the gods, attacking only the wicked who attempt to enter holy temples. While horrific in appearance, they aren't typically dangerous to humans and live on a diet of small birds and animals.

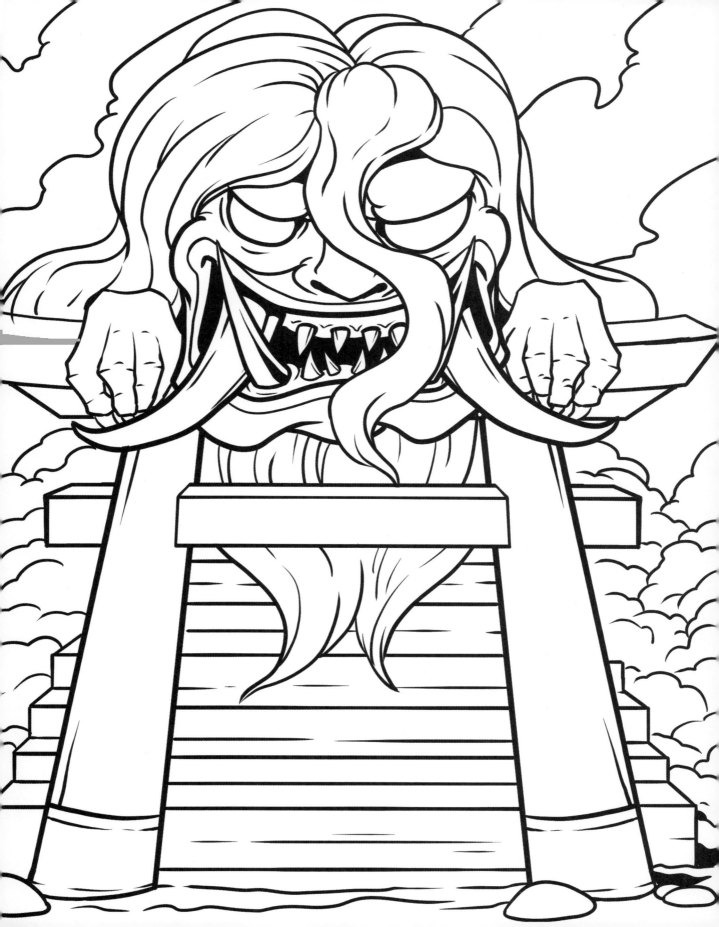

SHUSSEBORA しゅっせぼら

Giant, serpent-like creatures from the darkest depths of the sea, shussebora are ancient and mysterious. In order to become a yōkai, these slithering dragons are required to live three thousand years beneath the earth, then another three thousand years beneath the sea. If you find one emerging from a dark and damp cave after a landslide, grab your hunting gear because eating their flesh is rumored to grant eternal life.

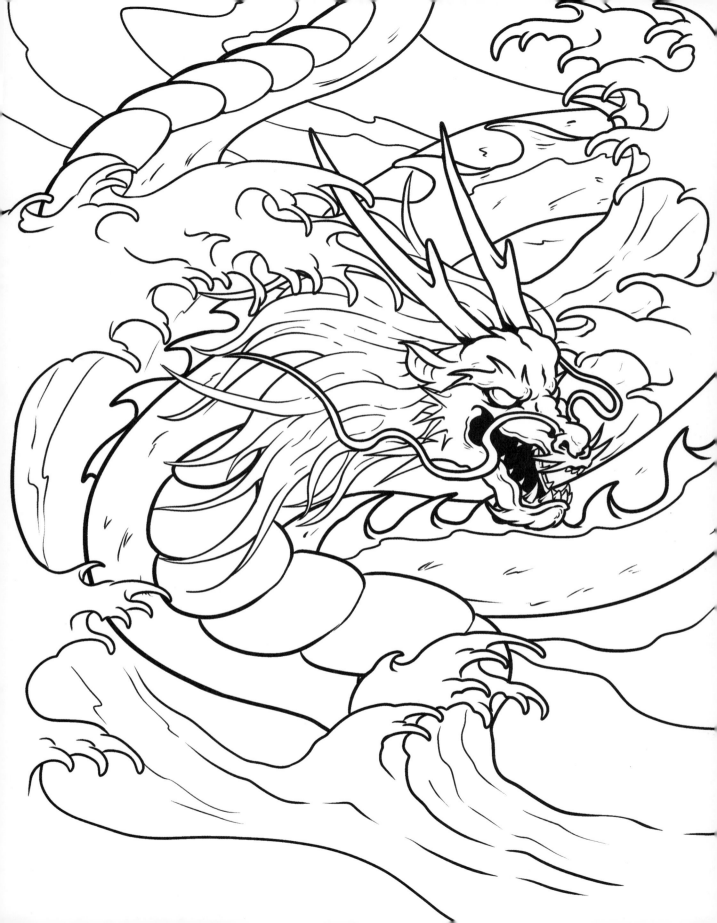

WA NYŪDŌ わにゅうどう

Wa nyūdō appears as the head of a man, usually a past sinner, trapped in a giant, flaming oxcart wheel. Trawling the earth for the souls of the wicked, these fearsome apparitions are in constant pain from the burning wheel and take pleasure in sharing that pain with others. Atone for your transgressions or you might find yourself dragged to the pits of hell to face brutal and eternal judgment.

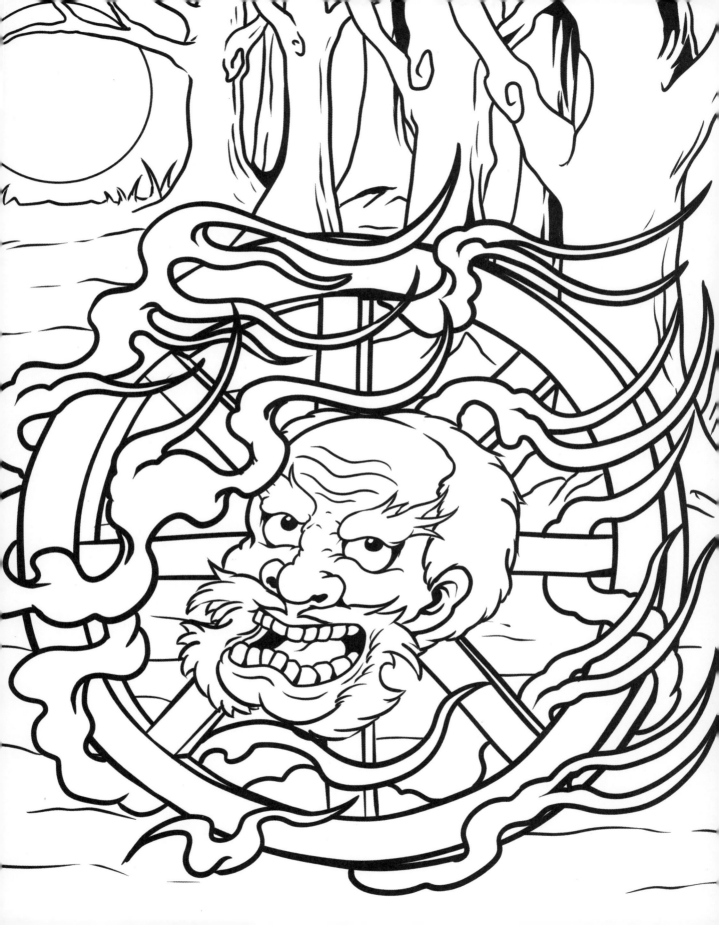

KODAMA こだま

Deep in the darkest and most ancient corners of the forests of Japan live the kodama, or tree spirits. They inhabit only the oldest trees and leave them to roam the woods only in the dark of night, tending to their groves and blessing the land with vitality. They can be seen as small orbs of light or tiny, ghostly humanoid figures. They are the life force of the tree they inhabit and depend on the tree to live, so if one of them dies, the other follows.

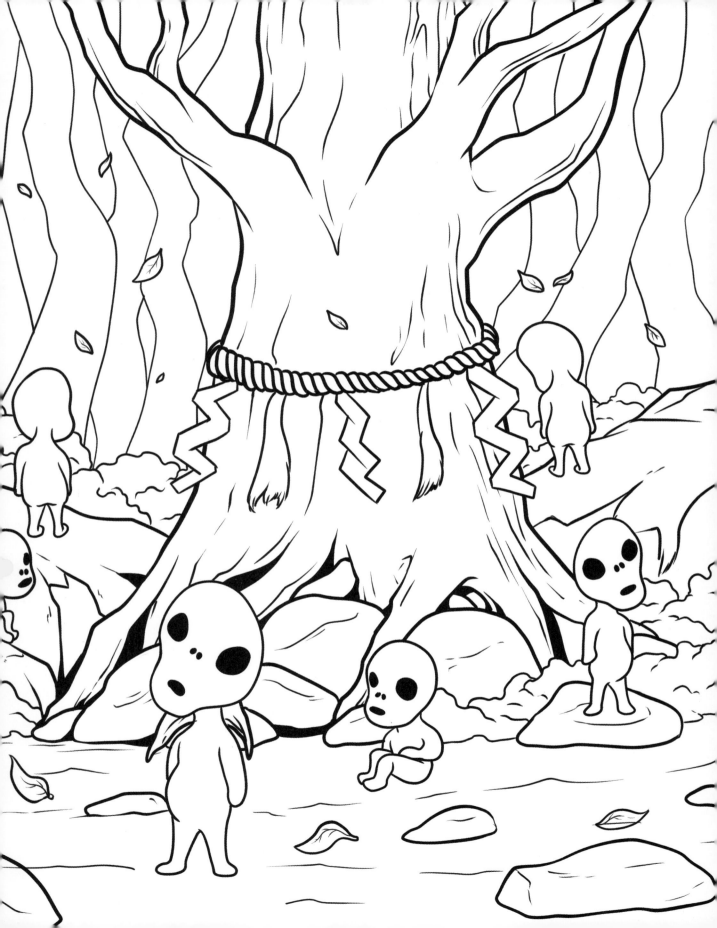

NEKOMATA ねこまた

Literally translated to mean "forked cat," these carnivorous bakeneko of the two-tailed variety walk around on hind legs and speak human languages. With their necromantic powers and penchant for fireball magic, they are extremely violent and dangerous to humans. They use their powers to enslave unfortunate souls and can control corpses like puppets.

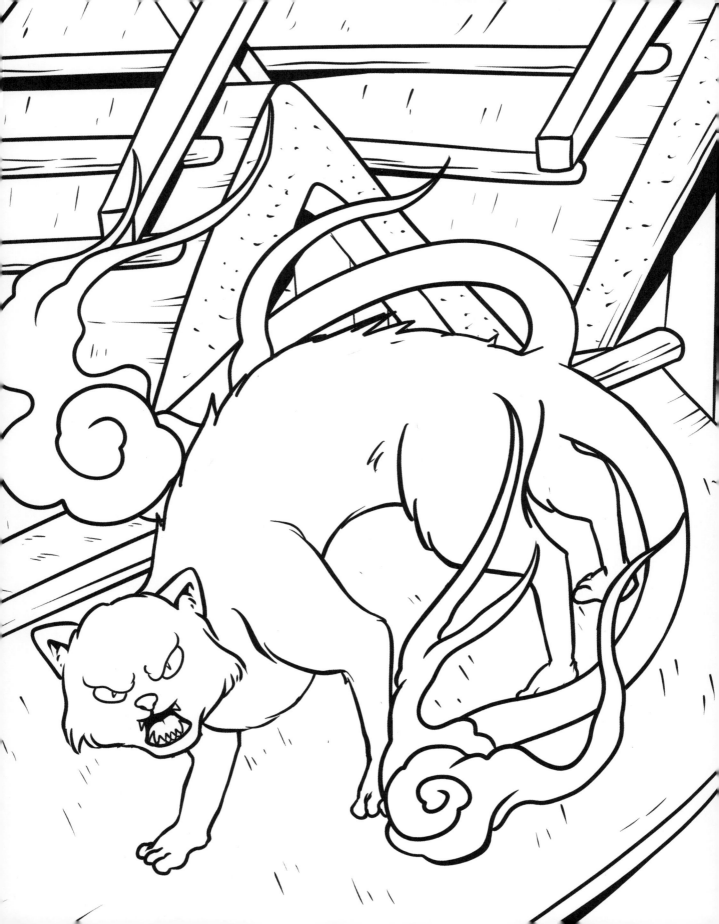

HITOTSUME-KOZŌ ひとつめこぞう

Lonely travelers have reported being startled by a one-eyed blue priest who seems to delight at a good spook in the impending dark of night. However, the only thing to be afraid of with these apparitions is in fact their ledger, where they keep track of each family's misdeeds, intent on reporting to the god of pestilence and bad luck who has merit to prosper for the year and who deserves to suffer for their sins.

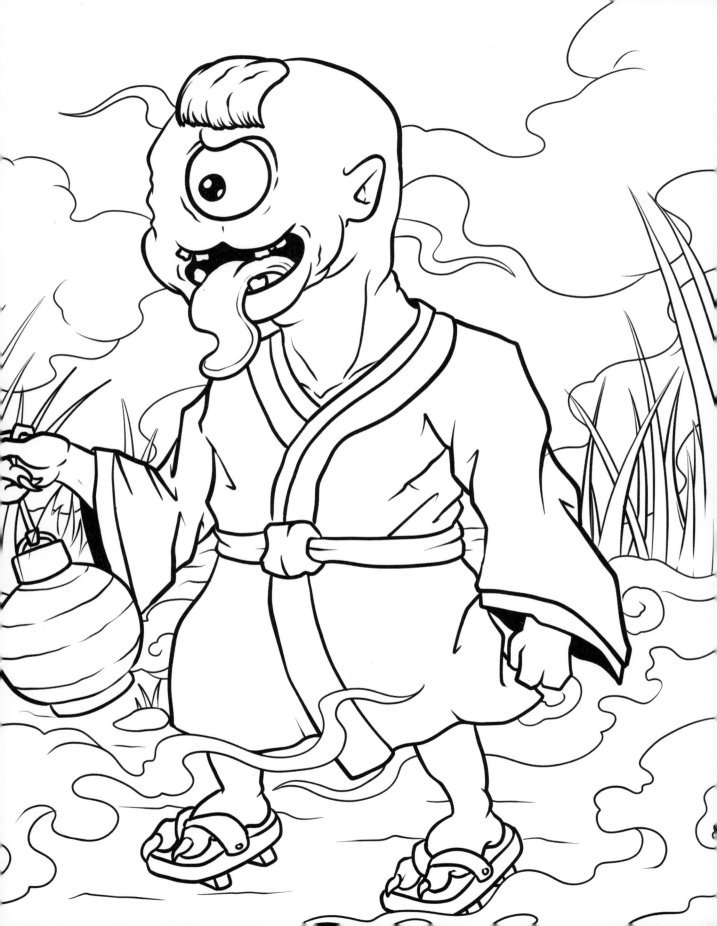

KUCHISAKE ONNA くちさけおんな

Translated to mean "slit-mouthed woman," the kuchisake onna has a gash cut across her mouth from ear to ear, calling to mind the DC Comics antihero Joker. But running into her in the dark is no laughing matter. Wearing a mask or veil, she will stop passersby and ask them if they think she is beautiful. Answer yes and she will reveal her grotesque gashes and ask again, "Kore demo?" (loose translation: "How about this?"). Scream or answer no and expect a mouth gash of your own. Lie to her and say yes at the risk of a brutal death.

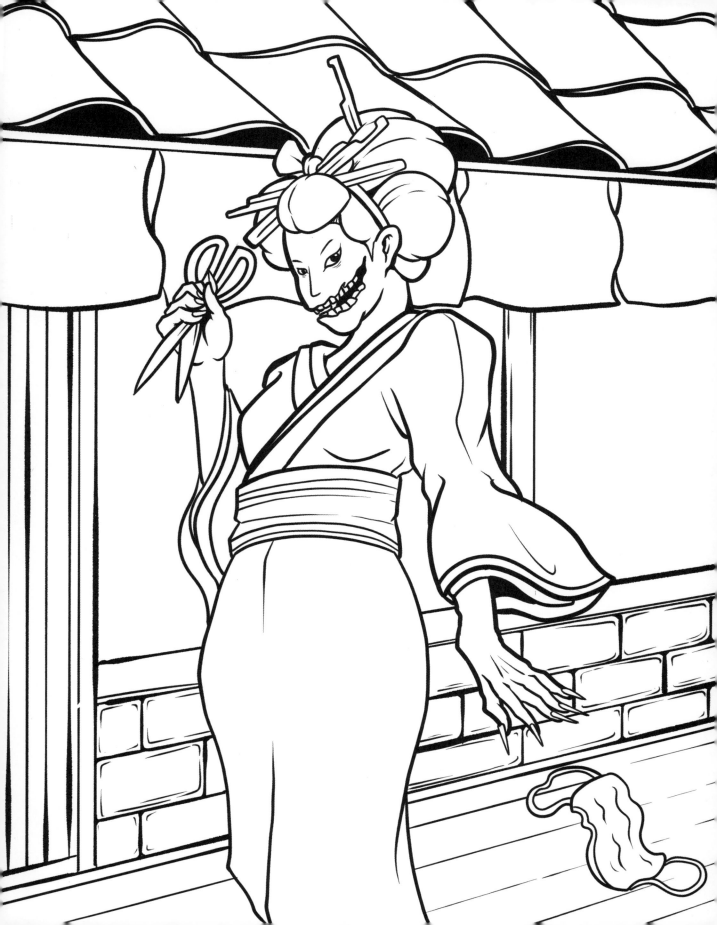

TSUCHIGUMO つちぐも

Known as the "purse web spider" in English, tsuchigumo are giant spiders who make their homes in spun-silk tubes, which they use to ambush large prey in the woods and forests of Japan. Known to be smart, they use their skills to trick humans into roaming near their webs, where they will pounce without hesitation. It is said that once, when an especially large tsuchigumo was killed, 1,990 human heads fell from its slain belly—a gruesome demonstration of its voracious appetite.

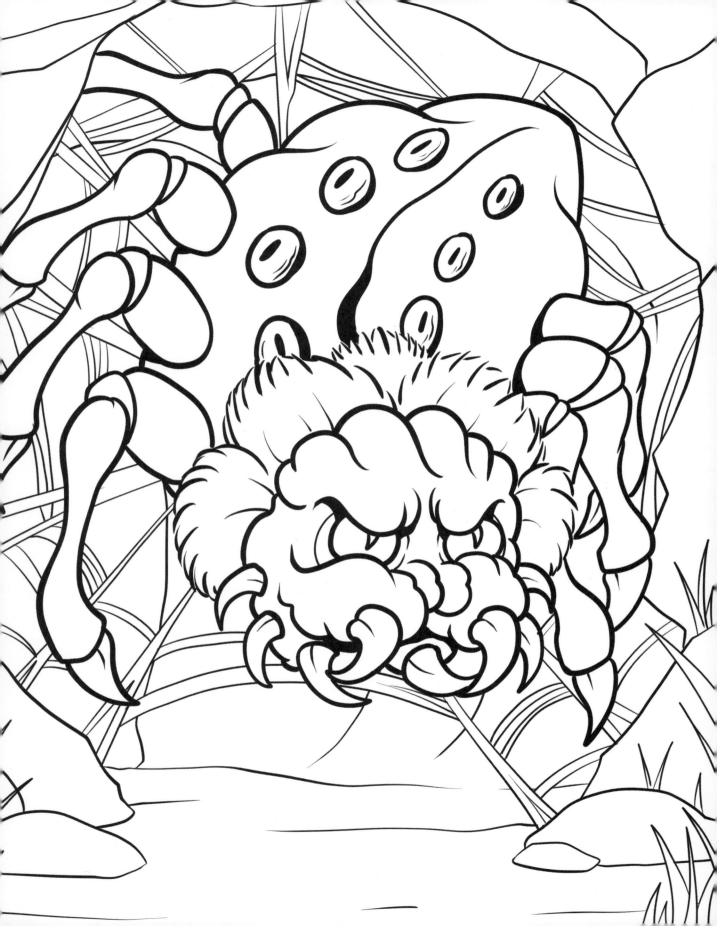

GENBU げんぶ

This dark emperor of the northern sky is usually seen as a turtle with a snake wrapped around it. Taking up residence between Sagittarius and Andromeda, genbu draws power from the Chinese element of water, rules the winter season, and takes up a partnership with the planet Mercury. A highly symbolic being, the turtle part of this creature is synonymous with longevity and immortality, while the snake represents reproduction and multiplicity.

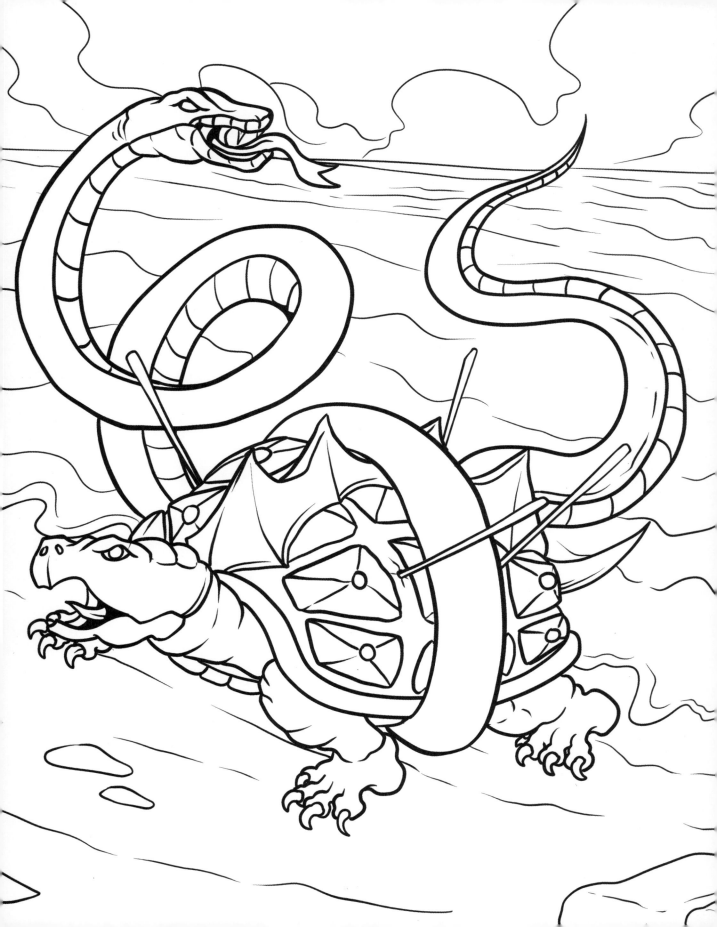

APPOSSHA あっぽっしゃ

On the first full moon of the Lunar New Year, the appossha crawl from the depths of the Sea of Japan to wander the villages at night in search of badly behaved children. They go from house to house, asking each family if their ill-mannered kids can be dragged beneath the frigid dark of the waves to live with them under the water. Even if they're told no, they might insist on staying unless offered a gift of mochi, which they will greedily snatch and run off with, leaving children to rethink their behavior for the coming year.

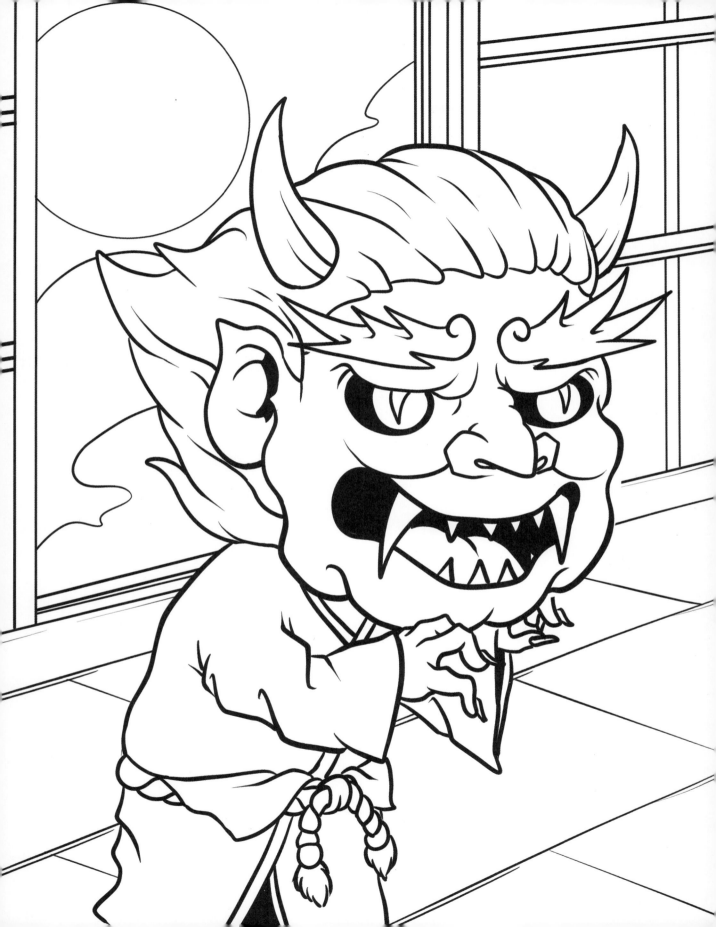

AKUGYO あくぎょ

An enormous mermaid in the classic sense of the word—donning the head and torso of a woman and the tail of a fish—akugyo are mysterious and antisocial creatures. Living beneath the waters surrounding Japan, they surface only on rare occasions. They are so large that boats can sometimes become moored on their mountainous backs, in which case the akugyo will likely slaughter everyone on board. Covered in scales with two white horns shooting from their brows, they can breathe fire when crossed, despite being surrounded by water.

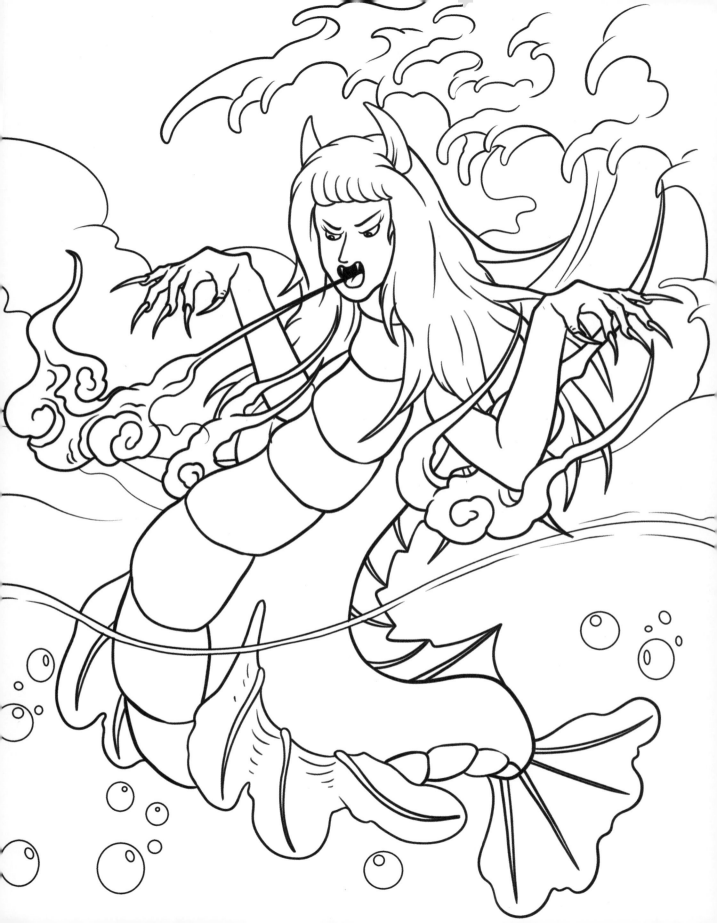

CHIKO ちこ

A high-ranking creature of the kitsune variety, chiko may appear to be normal foxes in their youth, but as they reach the ripened age of one hundred, the tails of the wise will begin to grow and multiply. As the years pass and their wisdom deepens, up to nine tails might be seen on any given chiko, making it evident at first glance how powerful they are. Whether they use that power for good or evil is always a gamble.

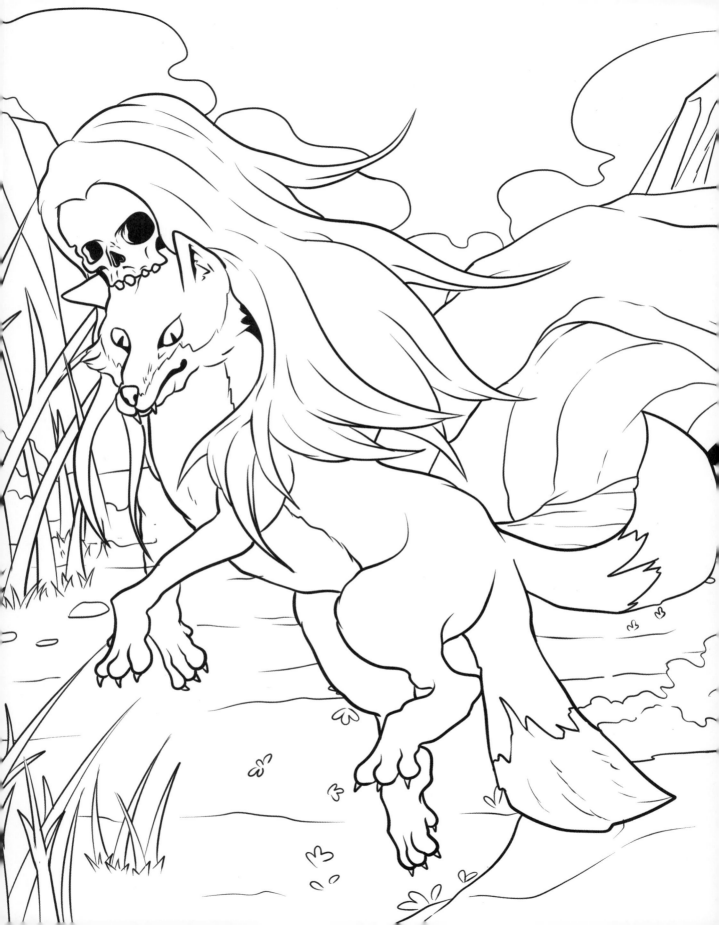

FUKURO MUJINA ふくろむじな

These "bag badgers" are cunning tricksters with a lesson to teach. They often appear as well-dressed humans with a bag over their shoulder, when in fact they are a badger of the magical sort. In his description of the fukuro mujina, Toriyama Sekien (an ukiyo-e artist of Japanese folklore born in 1712) equates their mystical mission statement with the saying, "Don't count your chickens before they hatch."

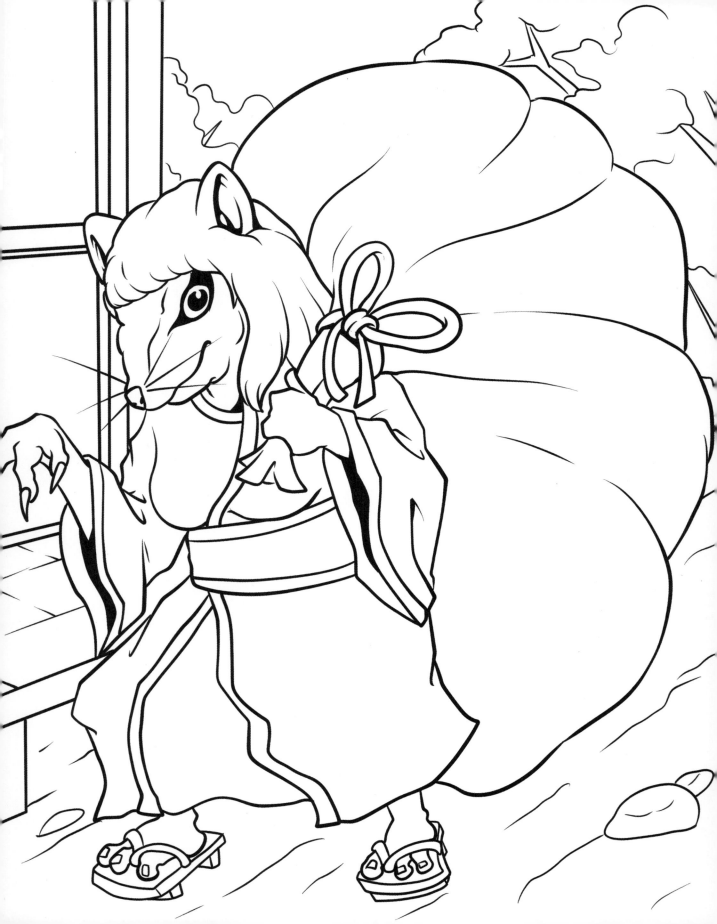

DATSUE-BA だつえば

In Japanese folklore depicting Buddhist hell, Datsue-ba is a screeching demoness who sits idly by the Sanzu River awaiting newly deceased humans who are ready to cross into the otherworld. Meeting her piercing gaze is unavoidable as she rips off her victim's clothes and hangs them from a tree branch to test their weight. The heavier the clothes, the further the branch bows, indicating a weightsome load of sins that determines where on the river one can cross into hell.

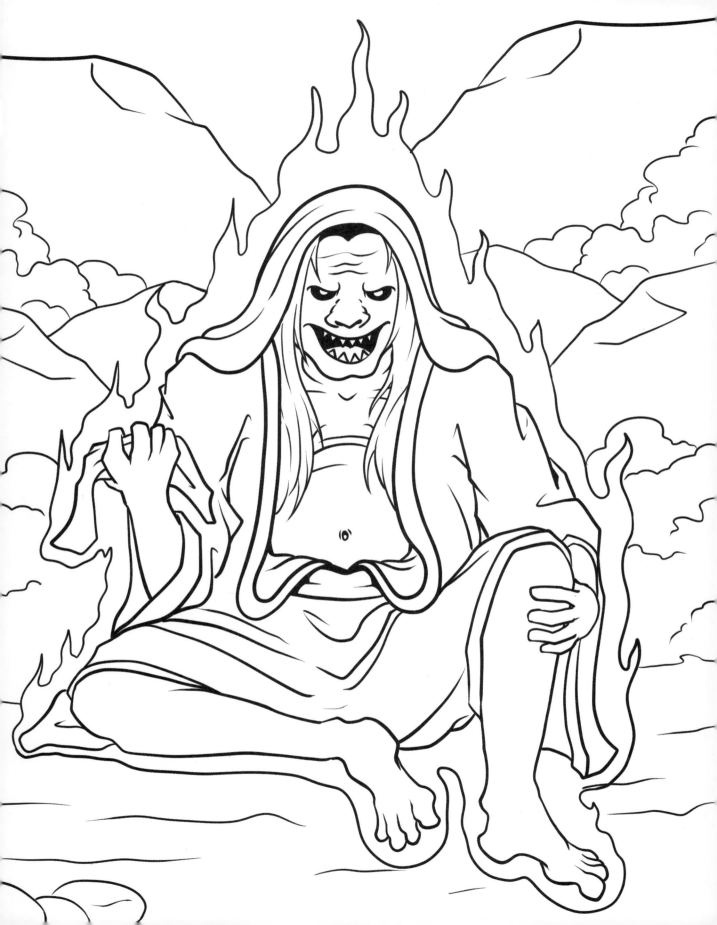

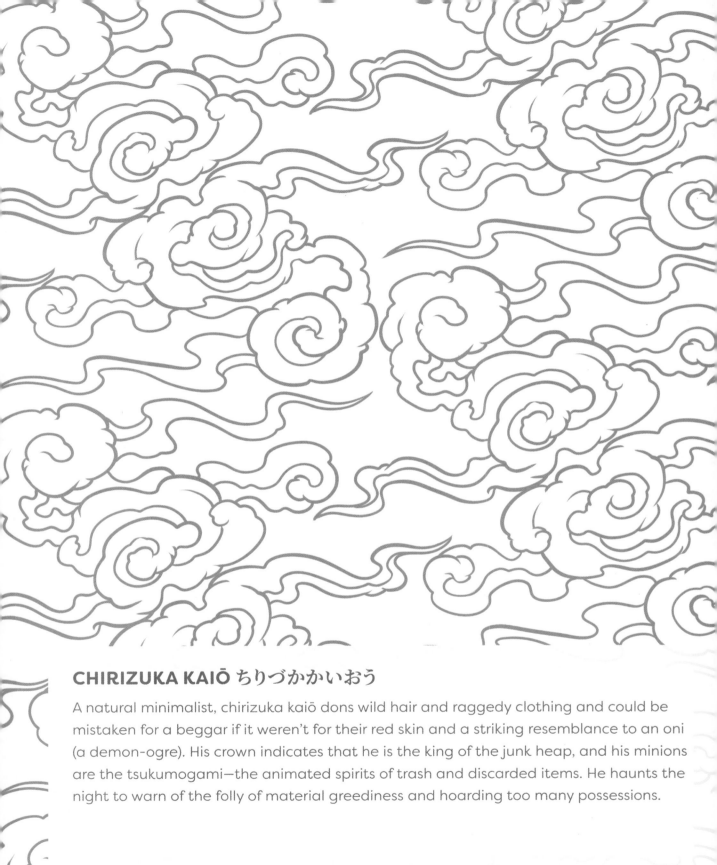

CHIRIZUKA KAIŌ ちりづかかいおう

A natural minimalist, chirizuka kaiō dons wild hair and raggedy clothing and could be mistaken for a beggar if it weren't for their red skin and a striking resemblance to an oni (a demon-ogre). His crown indicates that he is the king of the junk heap, and his minions are the tsukumogami—the animated spirits of trash and discarded items. He haunts the night to warn of the folly of material greediness and hoarding too many possessions.

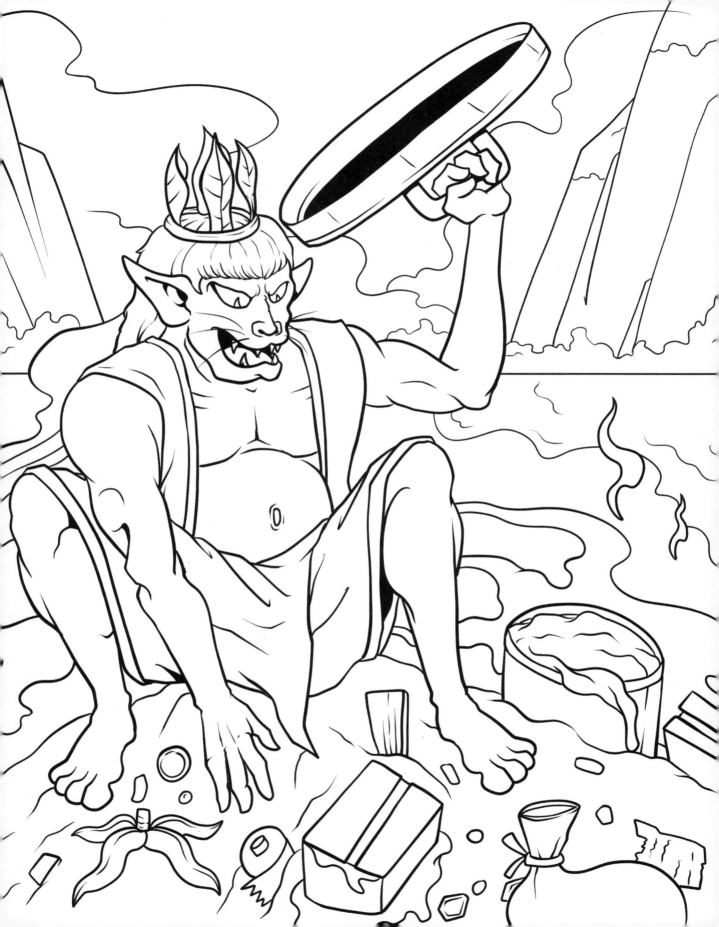

SUIKA NO BAKEMONO すいかのばけもの

Translated to mean "watermelon monster," suika no bakemono are samurais with a watermelon for a head. Although their crania may be edible, their time in the melon patch taught them a deep understanding of the magic of insects, and they'll harness those powers to enhance their samurai prowess, making them a formidable foe.

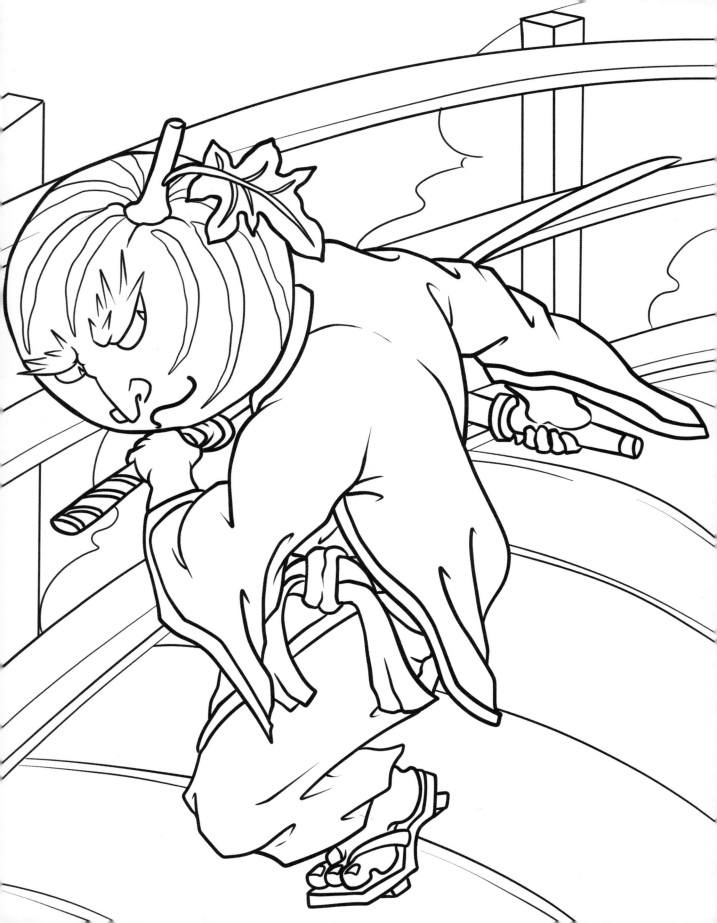

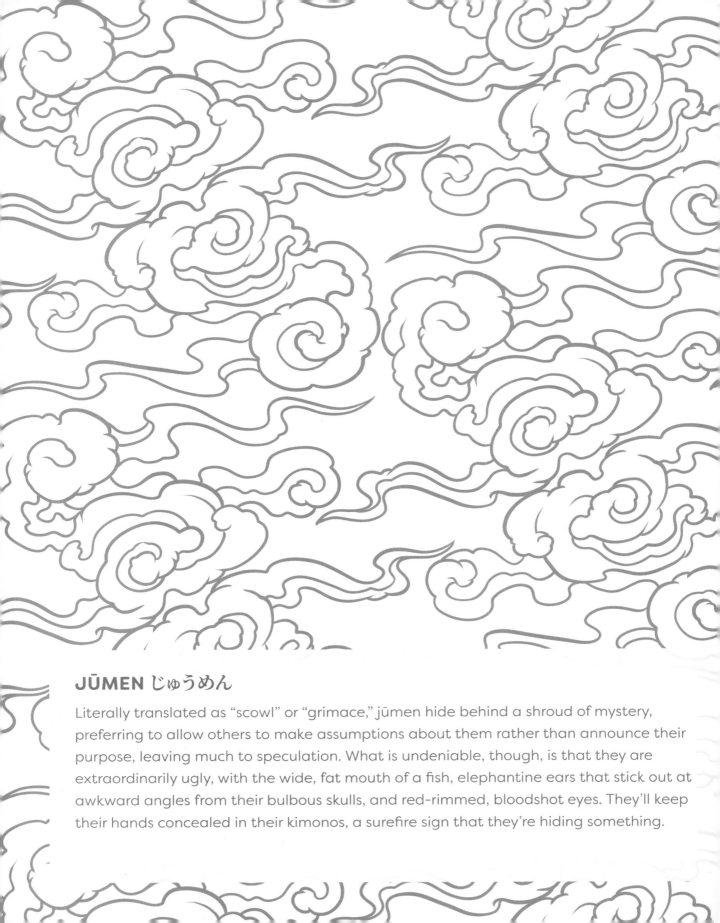

JŪMEN じゅうめん

Literally translated as "scowl" or "grimace," jūmen hide behind a shroud of mystery, preferring to allow others to make assumptions about them rather than announce their purpose, leaving much to speculation. What is undeniable, though, is that they are extraordinarily ugly, with the wide, fat mouth of a fish, elephantine ears that stick out at awkward angles from their bulbous skulls, and red-rimmed, bloodshot eyes. They'll keep their hands concealed in their kimonos, a surefire sign that they're hiding something.

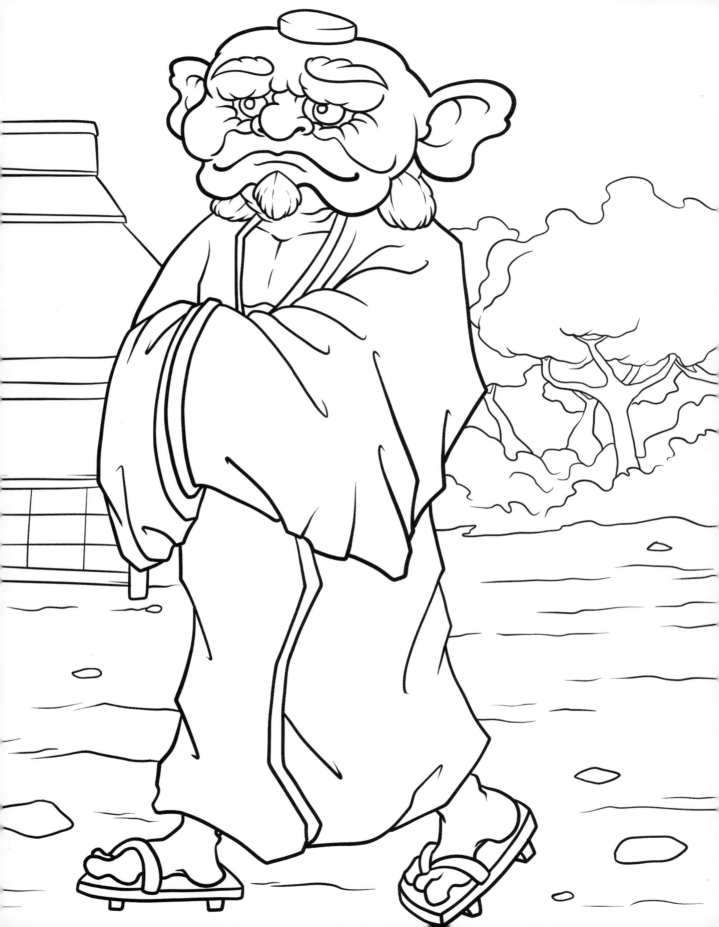

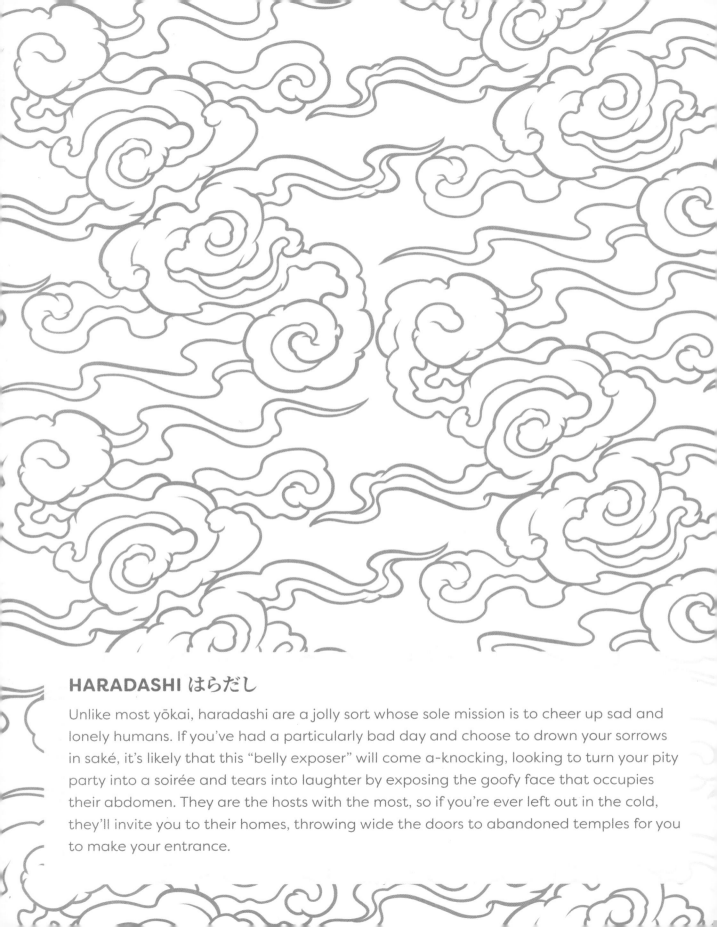

HARADASHI はらだし

Unlike most yōkai, haradashi are a jolly sort whose sole mission is to cheer up sad and lonely humans. If you've had a particularly bad day and choose to drown your sorrows in saké, it's likely that this "belly exposer" will come a-knocking, looking to turn your pity party into a soirée and tears into laughter by exposing the goofy face that occupies their abdomen. They are the hosts with the most, so if you're ever left out in the cold, they'll invite you to their homes, throwing wide the doors to abandoned temples for you to make your entrance.

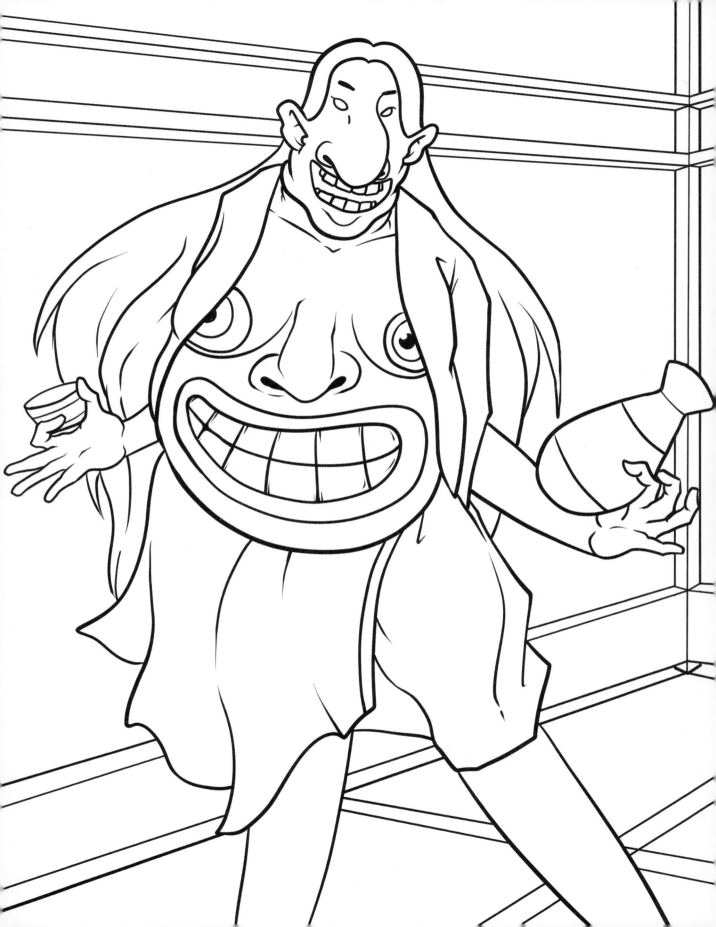

OBOROGURUMA おぼろぐるま

Echoing through the mists of a moonlit night, residents of Kyōto might hear the eerie screech of oxcart wheels. Upon stepping outside to investigate, they will discover this malevolent yōkai in the form of a ghostly cart with a grotesque face staring back at them. Parking is apparently an age-old problem because it is said that they feed on the fury of ancient nobles, angry that they couldn't find a suitable spot to park their oxcarts on the busy streets of Kyōto.

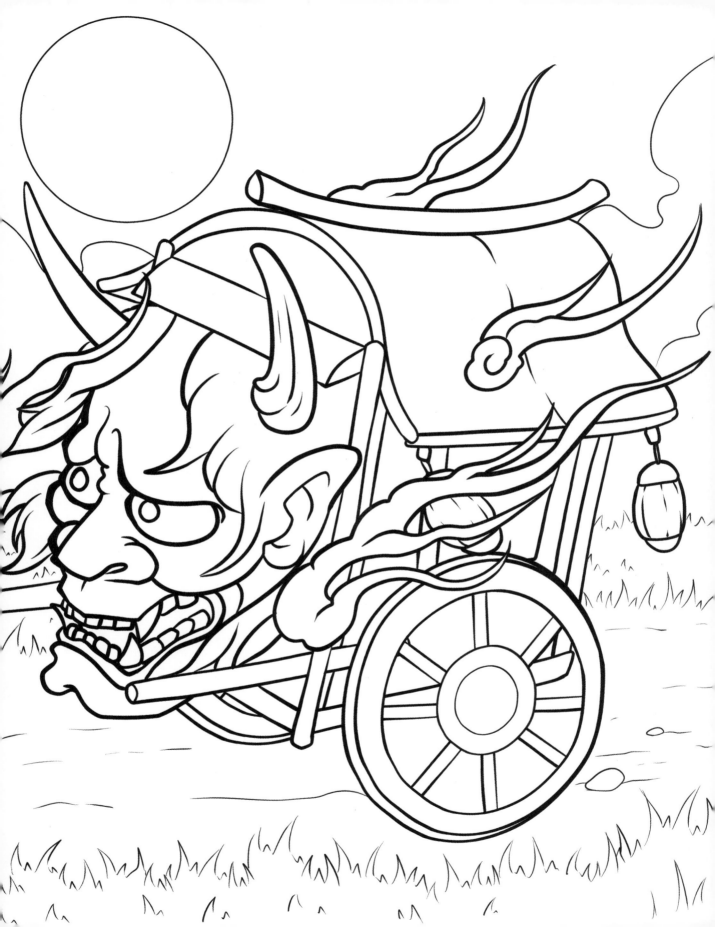

IPPONDATARA いっぽんだたら

Deep in the mountains of Japan, a lucky hiker might spot the shy ippondatara hopping around on a singular leg, using their cycloptic eye to navigate. Typically more afraid of humans than humans are of them, these sheepish individuals choose violence once every year on December 20, stomping on and crushing the brave souls who dare to enter the forest on this day.

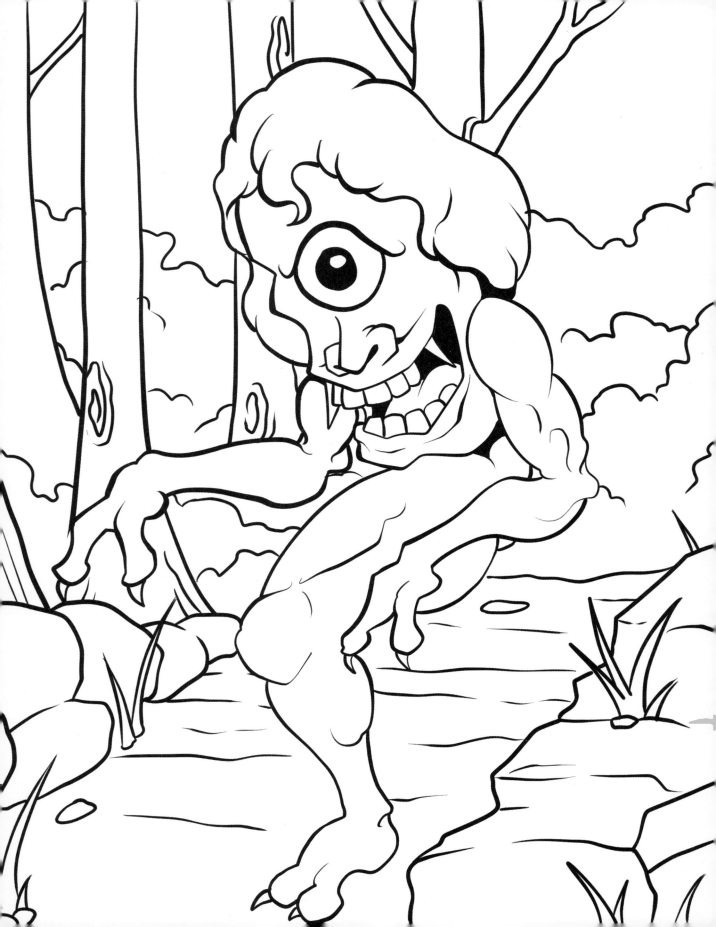

TAKIYASHA HIME たきやしゃひめ

Translated to mean "waterfall demon princess," Takiyasha hime was the daughter of Taira no Masakado, an Eastern Japanese Heian period provincial magnate (gōzoku) who attempted to overthrow the Kyōto government in the tenth century. While accounts differ on exactly how this sorceress obtained her magical powers, it is widely agreed upon that she holds the secrets to frog magic and Onmyōdō, a form of alchemy and divination that draws from astronomy and the natural world.

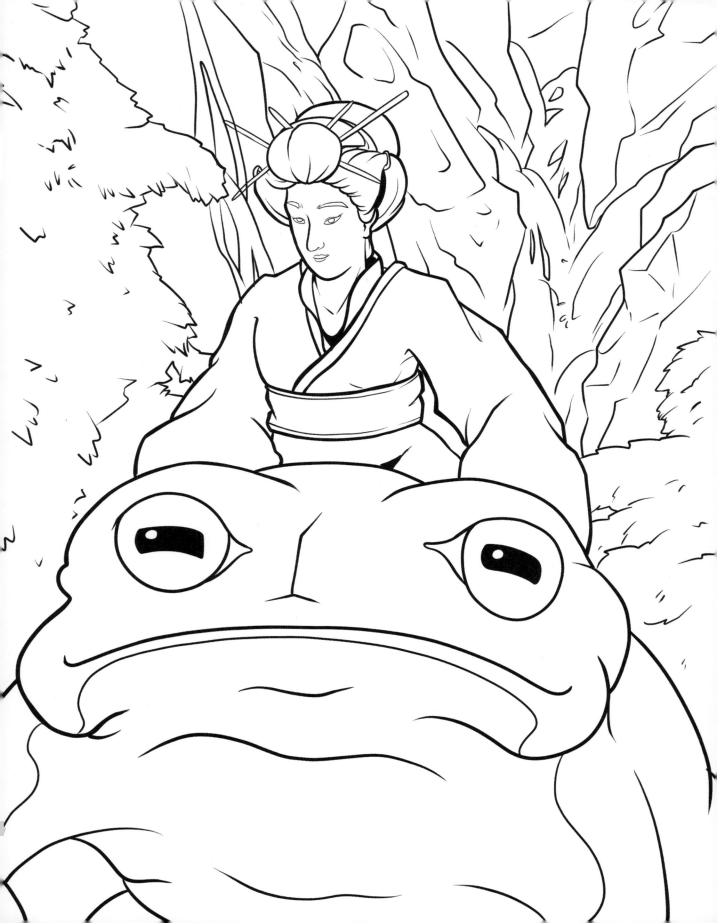

MOMONJII ももんじい

Otherwise known as the "hundred hundred geezer"—meaning he's really, really old—momonjii is born from the geriatric nobusuma (a long-lived bat-like yōkai). Ancient, beastly, and mangled with age, this grizzly apparition wanders dark roads and mountain passes, launching terrible assaults upon unsuspecting passersby, particularly unruly or crying children. When the road becomes forsaken and the wind begins to howl, travelers might find themselves violently ill upon encountering this restless beast.

MUMASHIKA むましか

Known as the jokester of the yōkai world, this silly demon has the body and hooves of a deer and the head of a horse with one large, goofy eye. With fangs protruding from the sides of its horsey mouth and a singular horn jutting from the back of its head, this twisted version of a reverse unicorn dances around with laughable absurdity, waving gangly hooved arms. Some believe that when you act a fool, you've been possessed by this goofball.

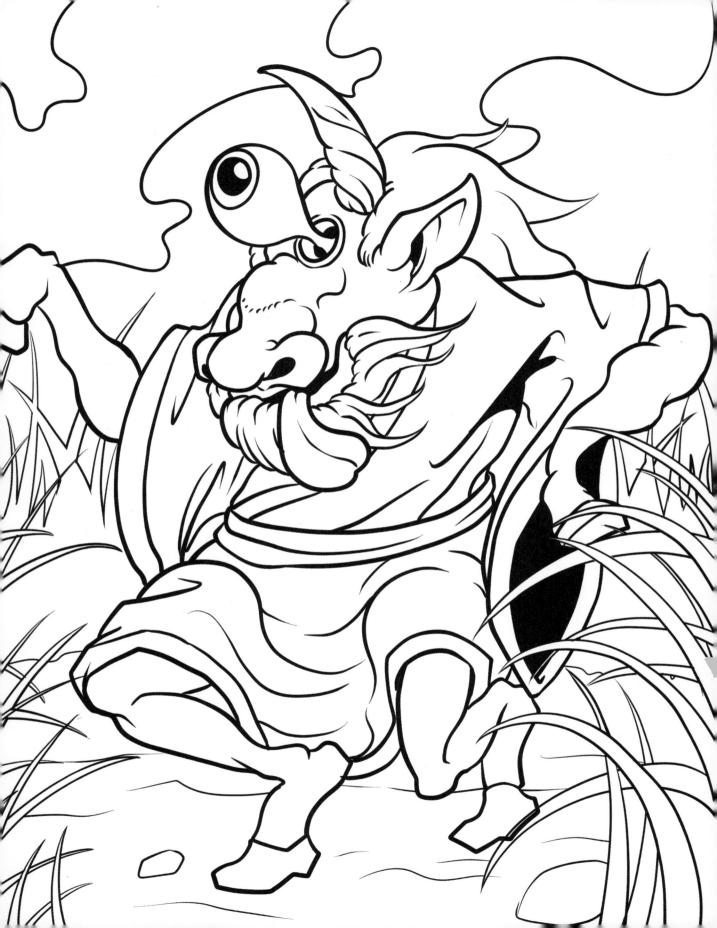

MIKOSHI-NYŪDŌ みこしにゅうどう

Solitary travelers on dark, lonely roads might come upon a seemingly meek and humble monk traversing the opposite direction. The wise will keep their heads bowed and keep walking, but the foolhardy will look the monk in the eyes, causing him to instantly shoot upward lightning-fast to an inexplicably tall height—so fast, in fact, that the traveler is knocked off kilter and falls backward. That's when this humble priest-turned-demon will literally go for the jugular, gnashing their sharp teeth and ripping out the throat of the stunned voyager.

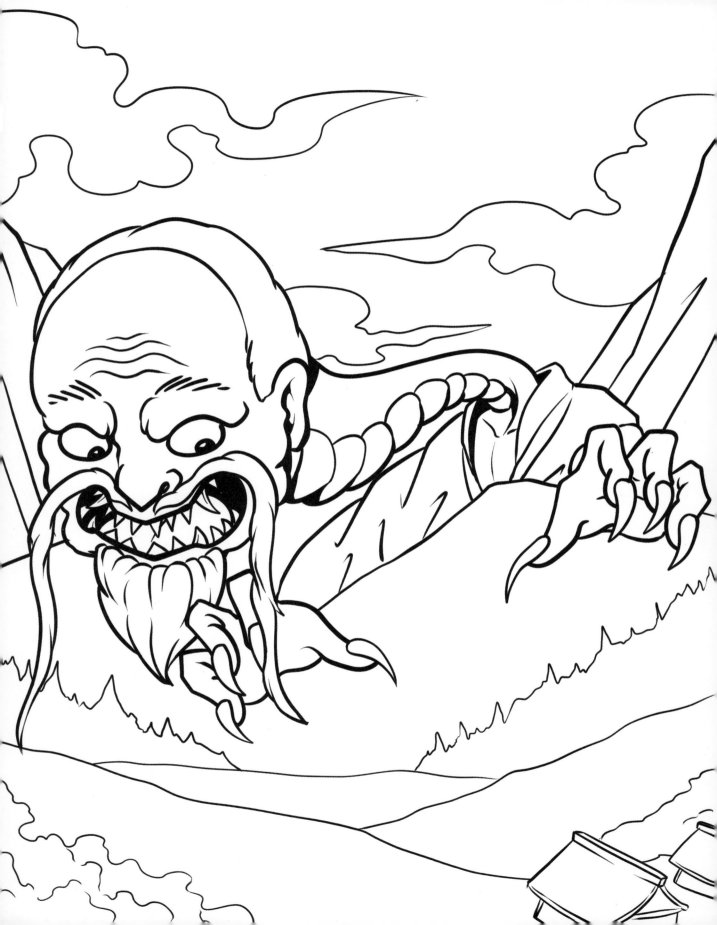

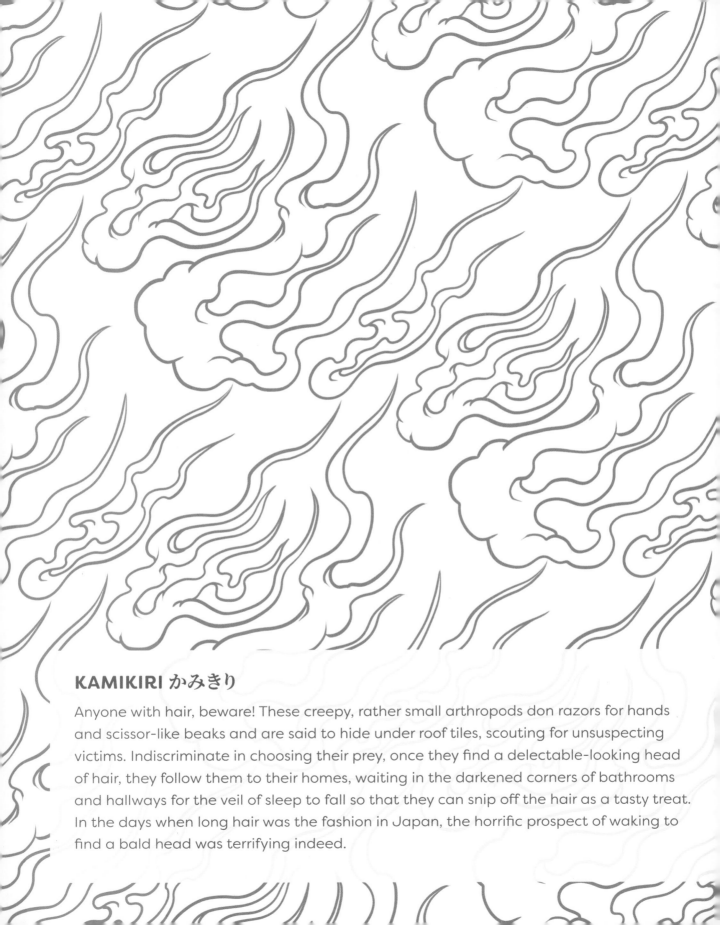

KAMIKIRI かみきり

Anyone with hair, beware! These creepy, rather small arthropods don razors for hands and scissor-like beaks and are said to hide under roof tiles, scouting for unsuspecting victims. Indiscriminate in choosing their prey, once they find a delectable-looking head of hair, they follow them to their homes, waiting in the darkened corners of bathrooms and hallways for the veil of sleep to fall so that they can snip off the hair as a tasty treat. In the days when long hair was the fashion in Japan, the horrific prospect of waking to find a bald head was terrifying indeed.

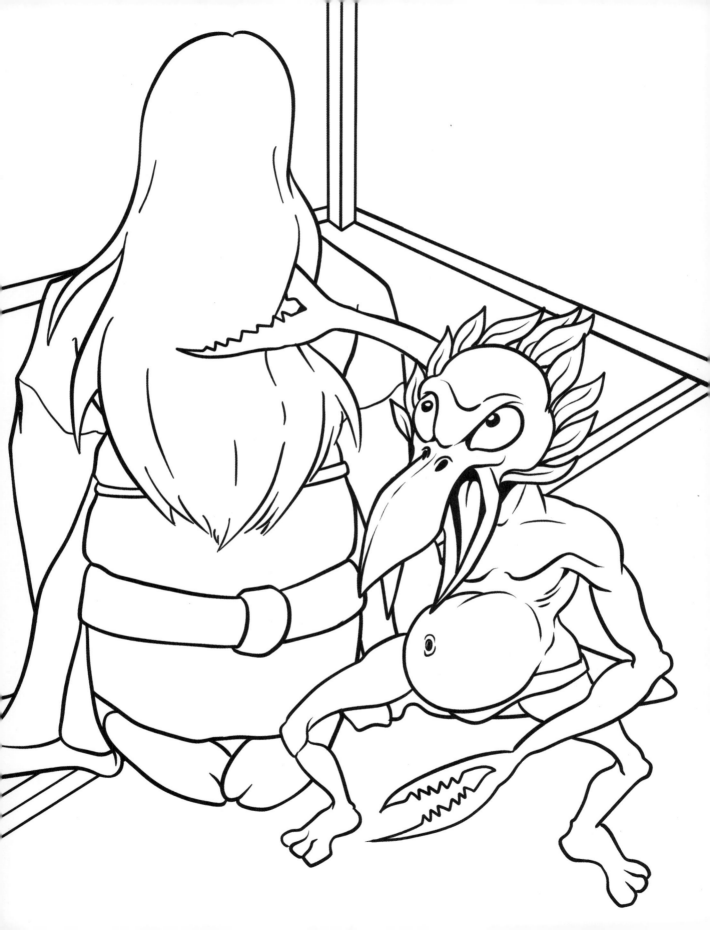

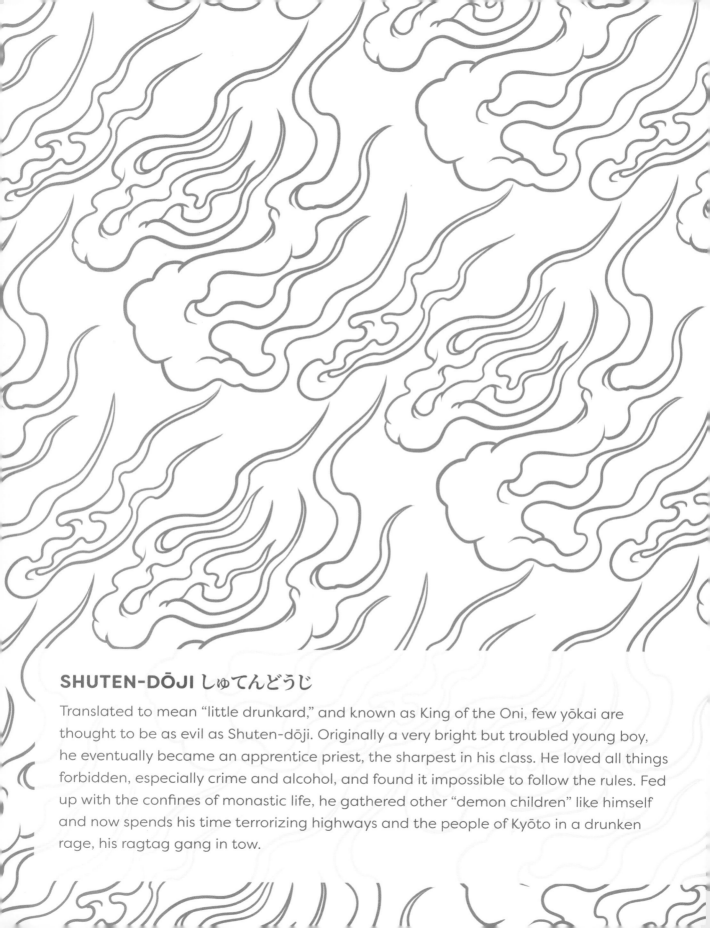

SHUTEN-DŌJI しゅてんどうじ

Translated to mean "little drunkard," and known as King of the Oni, few yōkai are thought to be as evil as Shuten-dōji. Originally a very bright but troubled young boy, he eventually became an apprentice priest, the sharpest in his class. He loved all things forbidden, especially crime and alcohol, and found it impossible to follow the rules. Fed up with the confines of monastic life, he gathered other "demon children" like himself and now spends his time terrorizing highways and the people of Kyōto in a drunken rage, his ragtag gang in tow.

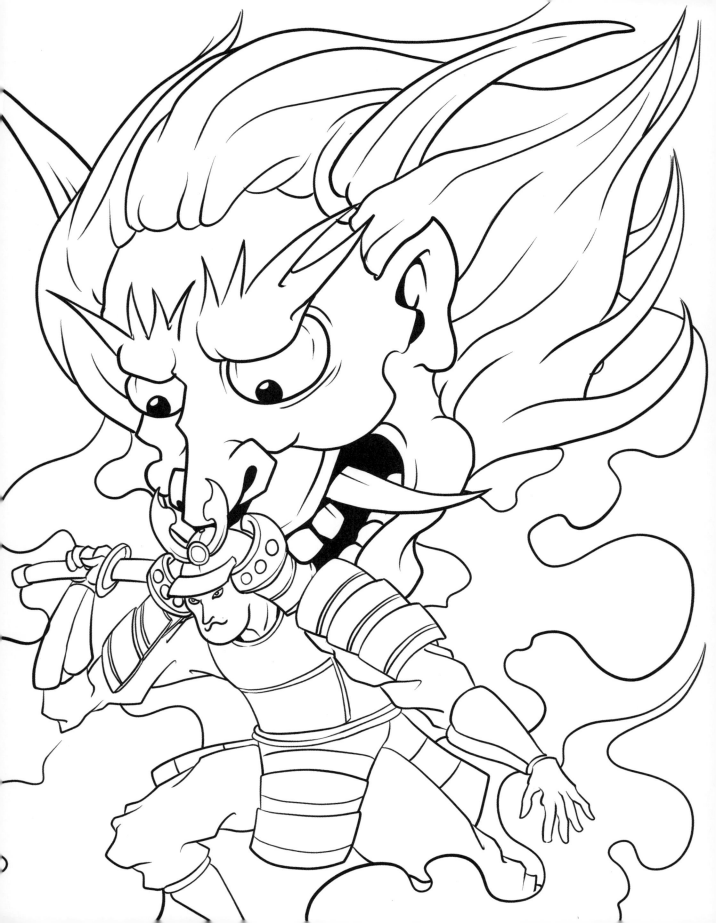

INUGAMI いぬがみ

Resembling an ordinary family dog in both appearance and behavior, an inugami is actually a *familiar,* a spirit of possession found in West Japan. When their true form is revealed, they appear to have a shriveled, mummified head and wear ceremonial garb and accessories. Rageful sorcerers were said to create these beings through monstrous and distasteful ceremonies so that they could use these loyal companions for various nefarious misdeeds. They can be passed down from one generation to the next, like a grotesque and twisted inheritance.

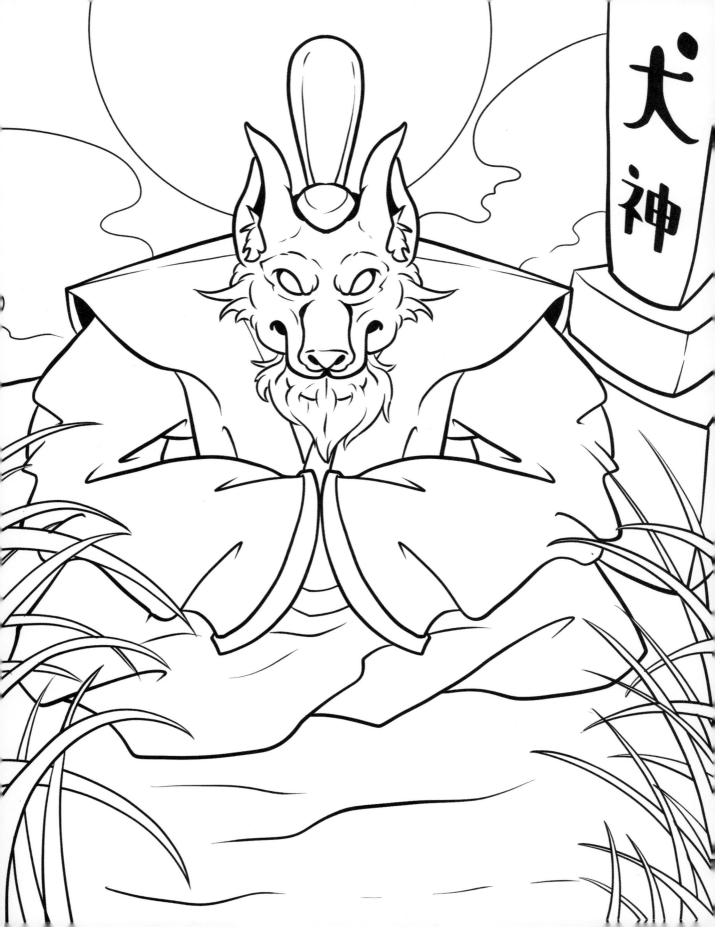

CHIMI ちみ

Chimi are spirits that live in dense forests, mountain stones, swamps, and other forms of nature. With the face and head of a human and the body of a beast, these monsters feed on the innards of humans and spread disease wherever they may roam. Beware of them on hikes and nature walks because they love to trick humans into getting lost so that they are easy prey.

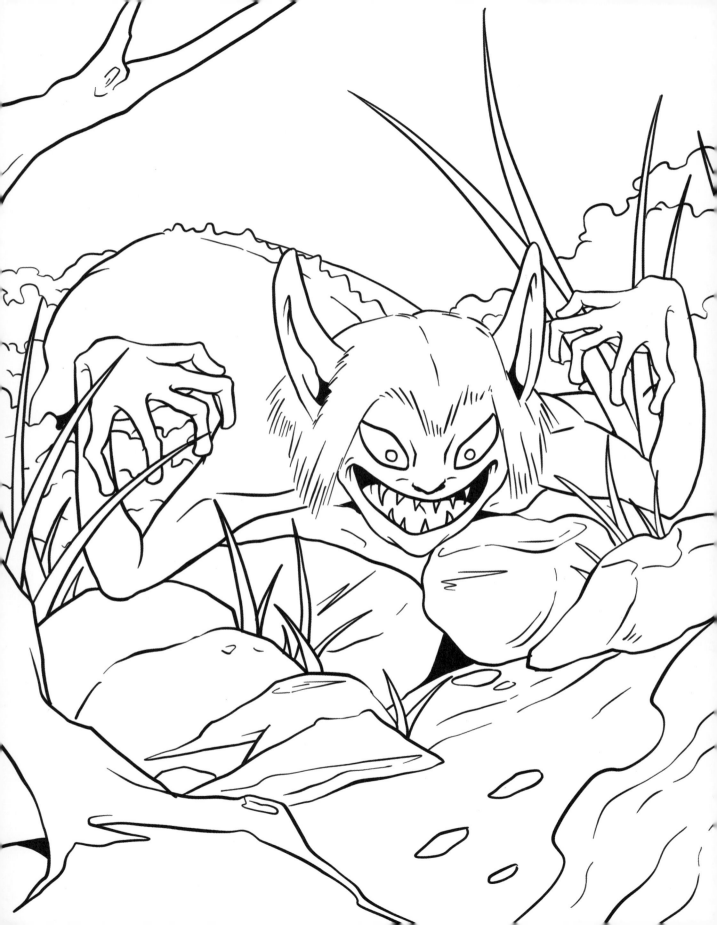

TŌFU KOZŌ とうふこぞう

Translated to mean "little tofu boy," tōfu kozō appear as children with bloated heads and claws for feet. Shy and weak, they are typically the brunt of jokes and tend to take on a servant role to larger, more powerful yōkai. These cowardly creatures are not often dangerous to humans, but an unwitting adult might glance behind them on a rainy night to find one sullenly following them home.

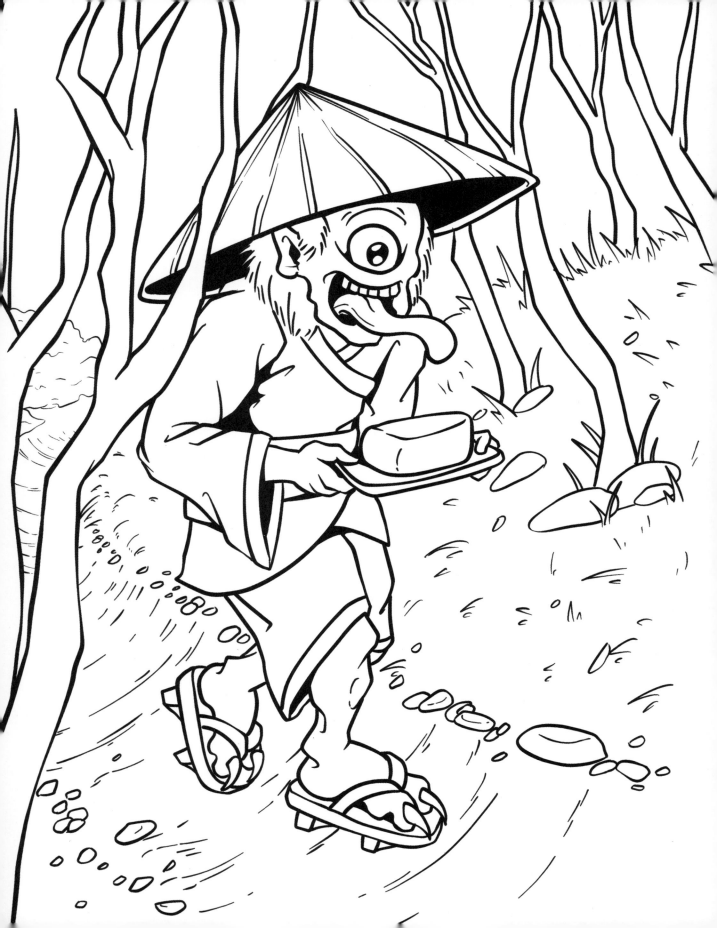

KAZENBŌ かぜんぼう

On the highest reaches of the Toribeyama mountain near Kyōto can be spotted monks completely immersed in flames that never fully consume them. Hikers might be startled when these apparitions materialize, due to the horrific appearance of burning skin and mournful, tortured cries. This yōkai was likely at least partially inspired by monks who offered themselves up as ritual sacrifice by self-immolation in the tenth century.

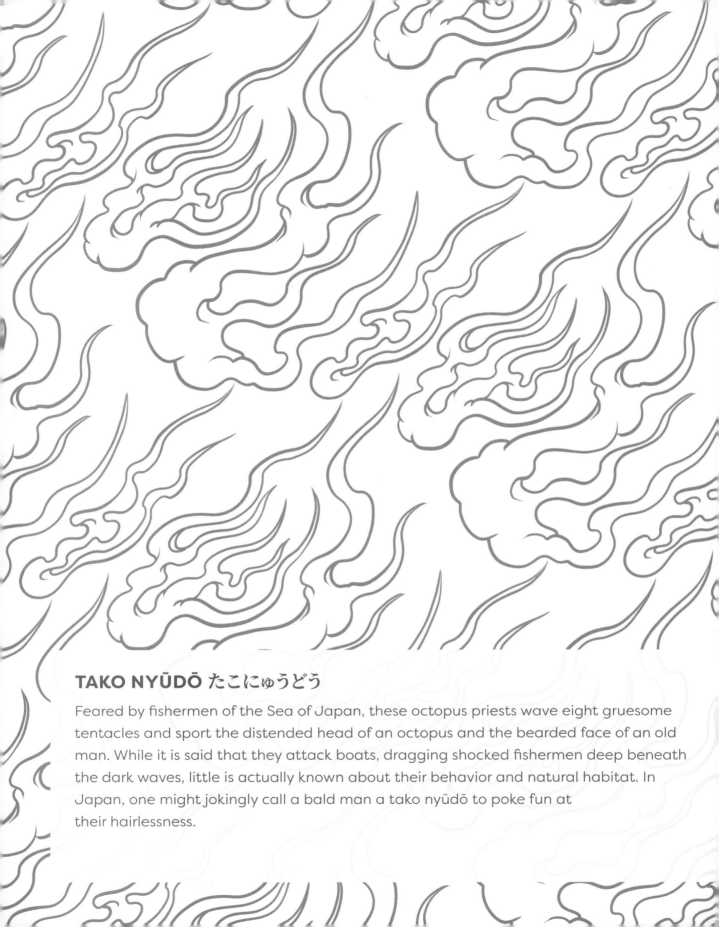

TAKO NYŪDŌ たこにゅうどう

Feared by fishermen of the Sea of Japan, these octopus priests wave eight gruesome tentacles and sport the distended head of an octopus and the bearded face of an old man. While it is said that they attack boats, dragging shocked fishermen deep beneath the dark waves, little is actually known about their behavior and natural habitat. In Japan, one might jokingly call a bald man a tako nyūdō to poke fun at their hairlessness.

BEKATARŌ べかたろう

Bekatarō is a play on the name *Tarō*, who is said to have been a little boy who was constantly hungry. No matter how much food he was given, his appetite was never satiated. Eventually, frustrated and broke, his family kicked him out of the house, leaving him to roam the streets looking for food. He was so hungry that he began eating people, which transformed him into the bekatarō yōkai, with his greasy hair and wide, drooling mouth.

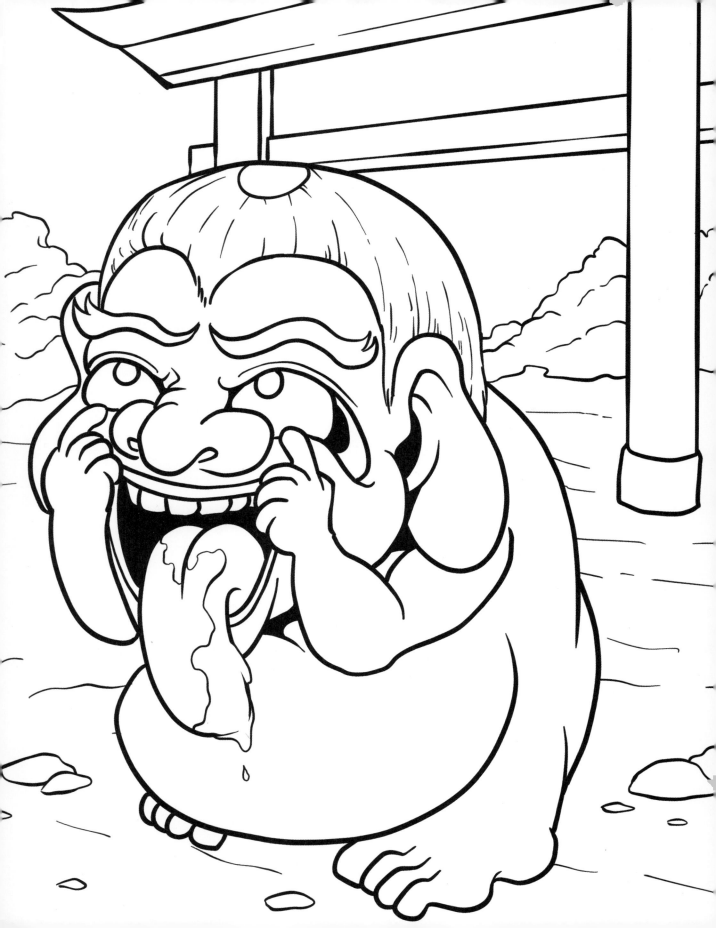

CHŌCHIN KOZŌ ちょうちんこぞう

On a dark, rainy night, a traveler might look behind them to find that they are being followed by a young boy with a cherry-red face, carrying a paper lantern to light the way. Chōchin kozō love to play games and will overtake the traveler so they can jump in front of them and stare them down menacingly, even though they are actually harmless. Described as "lantern priest boys," they're usually seen in areas where horrific crimes have happened, despite being peaceful themselves.

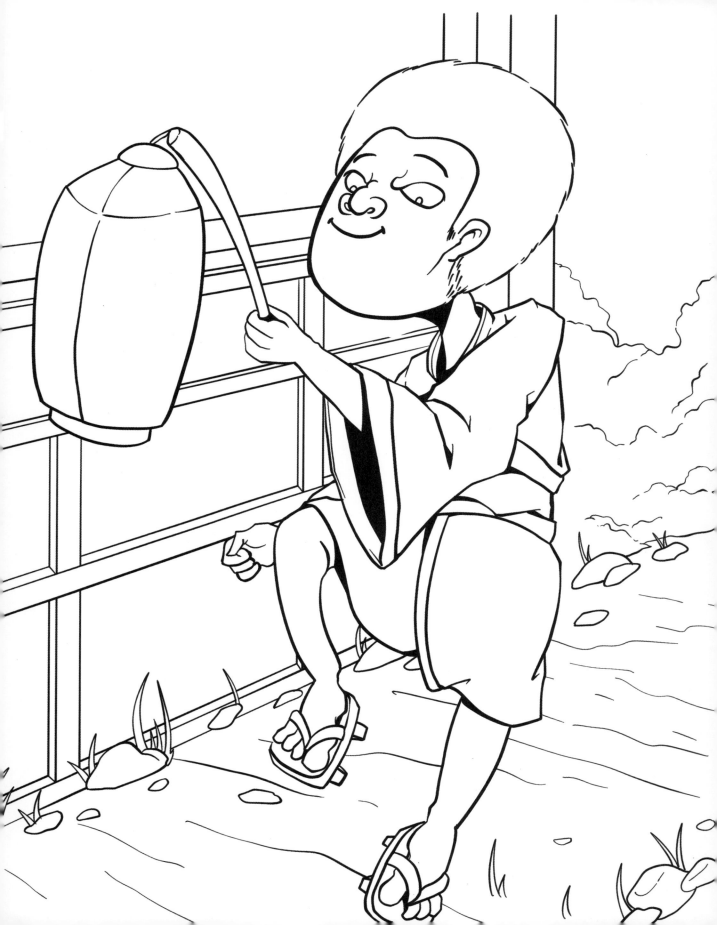

KARURA かるら

These hulking demigods have human bodies and the heads and wings of an eagle. Fearsome and terrifying, they breathe fire from their beaks. The flapping of their wings is the crack of thunder, a sound so powerful that it can dry up lakes, level forests, destroy homes, and create a blanket of darkness. Their greatest enemies are dragons, which they consume in ghastly feasts.

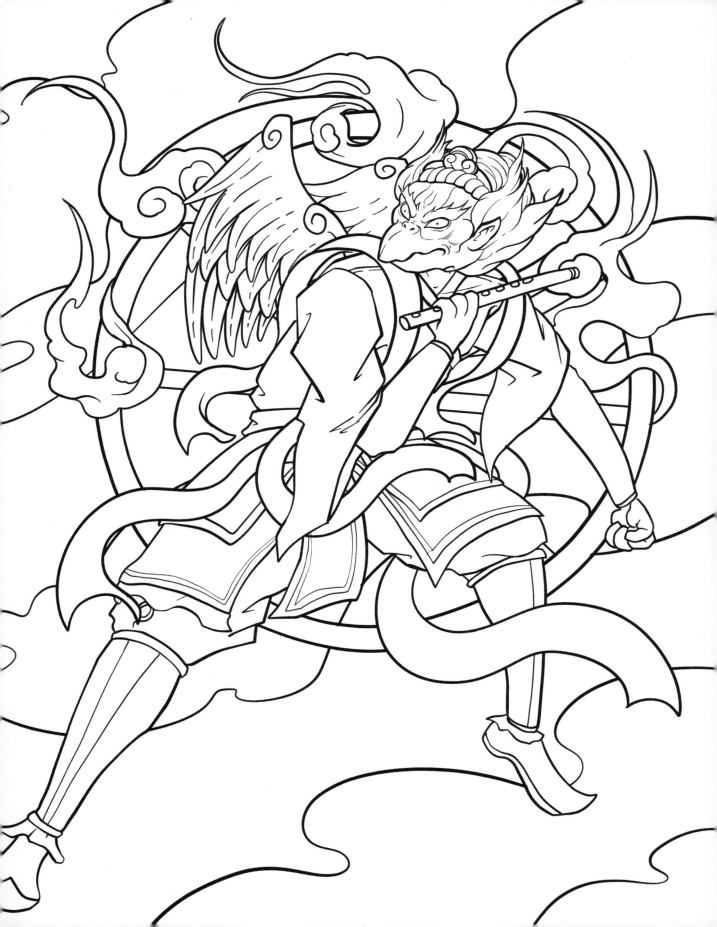

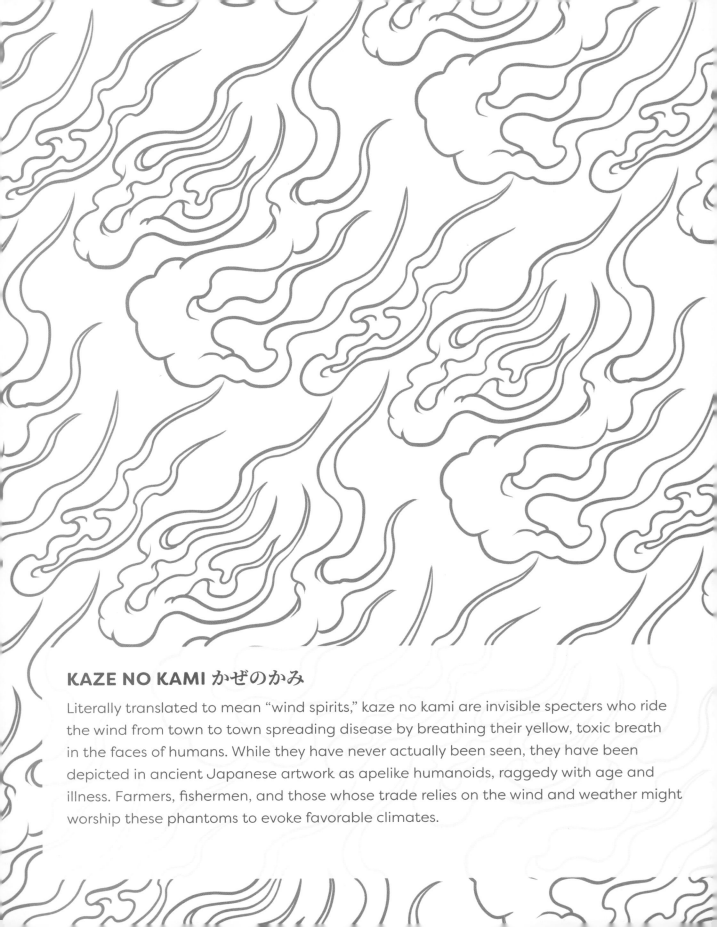

KAZE NO KAMI かぜのかみ

Literally translated to mean "wind spirits," kaze no kami are invisible specters who ride the wind from town to town spreading disease by breathing their yellow, toxic breath in the faces of humans. While they have never actually been seen, they have been depicted in ancient Japanese artwork as apelike humanoids, raggedy with age and illness. Farmers, fishermen, and those whose trade relies on the wind and weather might worship these phantoms to evoke favorable climates.

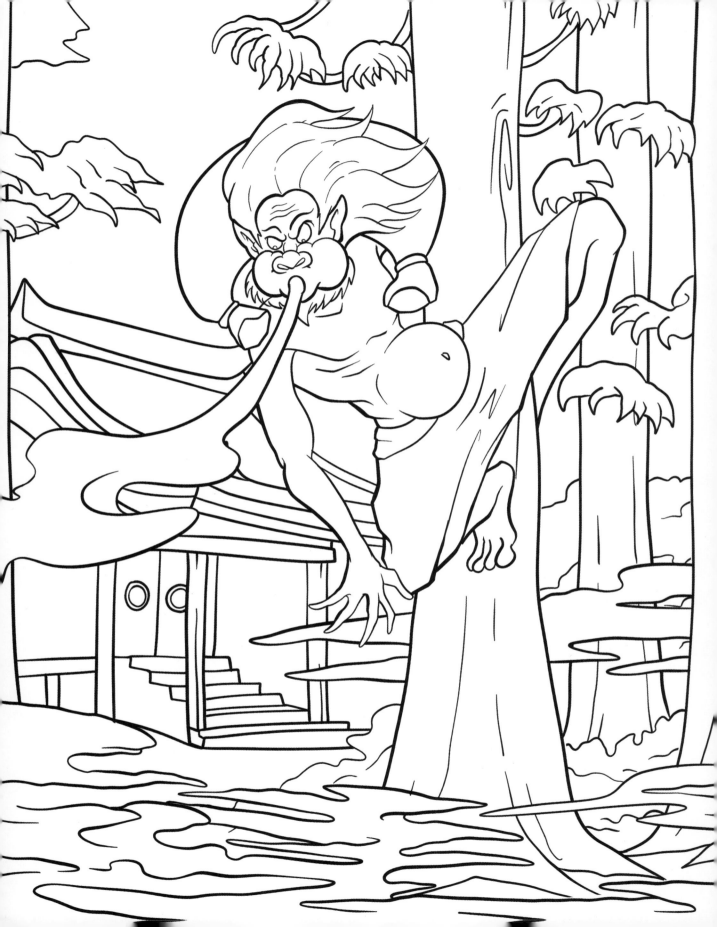

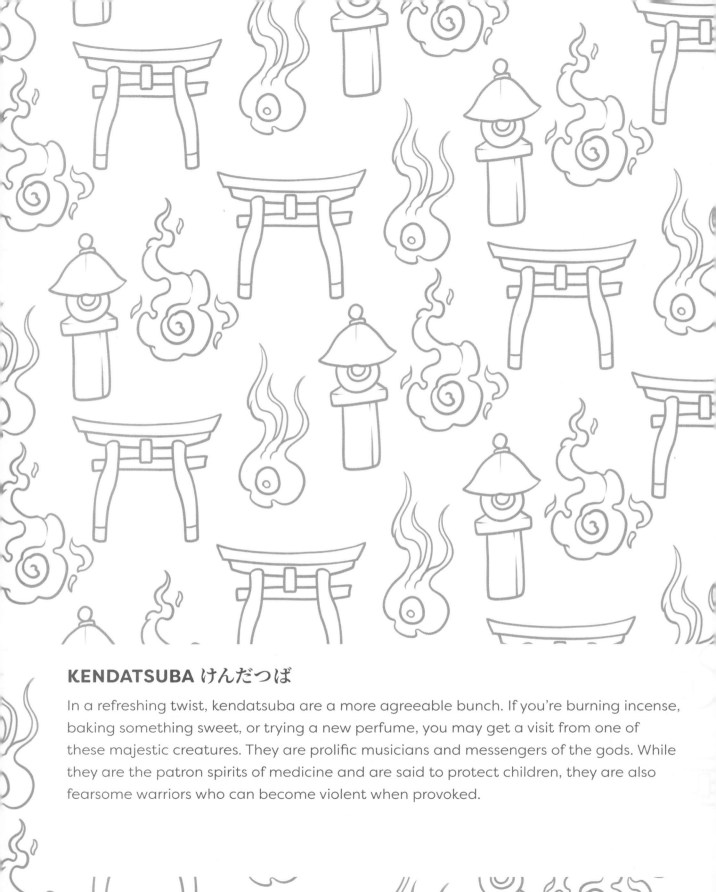

KENDATSUBA けんだつば

In a refreshing twist, kendatsuba are a more agreeable bunch. If you're burning incense, baking something sweet, or trying a new perfume, you may get a visit from one of these majestic creatures. They are prolific musicians and messengers of the gods. While they are the patron spirits of medicine and are said to protect children, they are also fearsome warriors who can become violent when provoked.

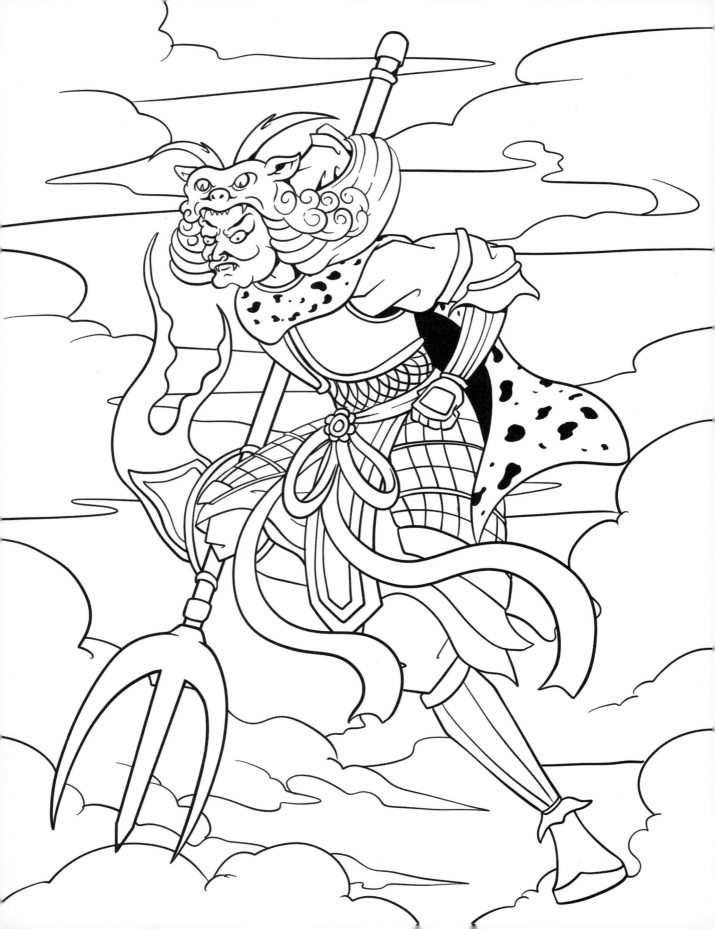

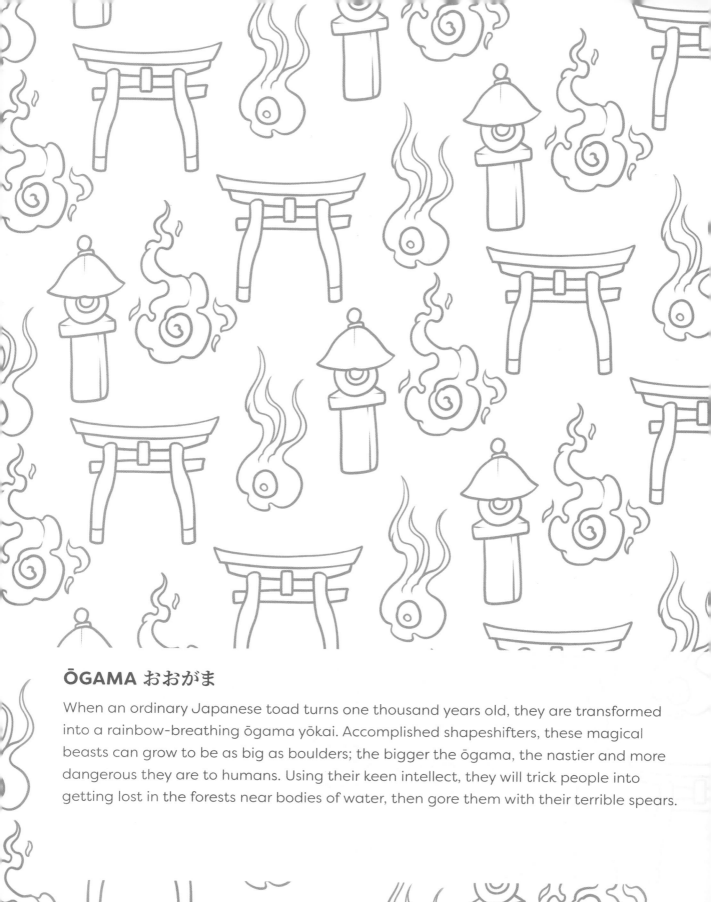

ŌGAMA おおがま

When an ordinary Japanese toad turns one thousand years old, they are transformed into a rainbow-breathing ōgama yōkai. Accomplished shapeshifters, these magical beasts can grow to be as big as boulders; the bigger the ōgama, the nastier and more dangerous they are to humans. Using their keen intellect, they will trick people into getting lost in the forests near bodies of water, then gore them with their terrible spears.

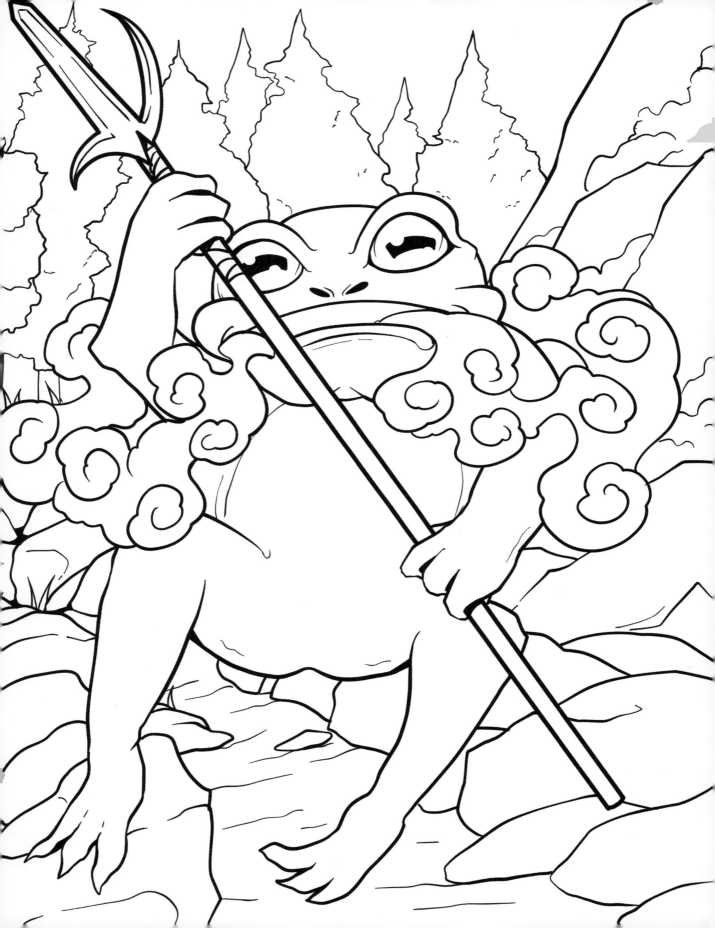

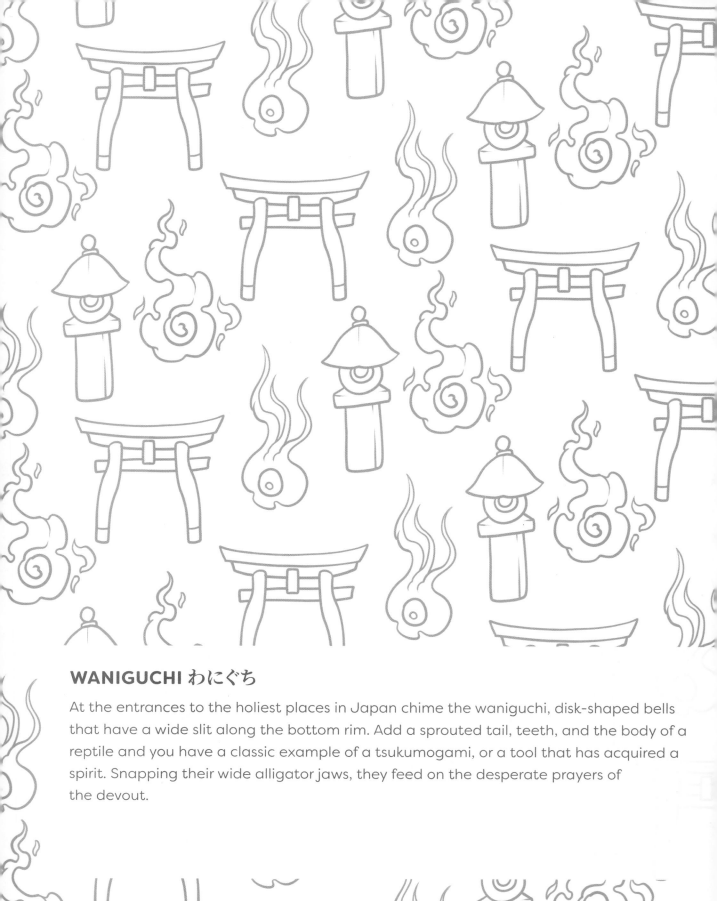

WANIGUCHI わにぐち

At the entrances to the holiest places in Japan chime the waniguchi, disk-shaped bells that have a wide slit along the bottom rim. Add a sprouted tail, teeth, and the body of a reptile and you have a classic example of a tsukumogami, or a tool that has acquired a spirit. Snapping their wide alligator jaws, they feed on the desperate prayers of the devout.

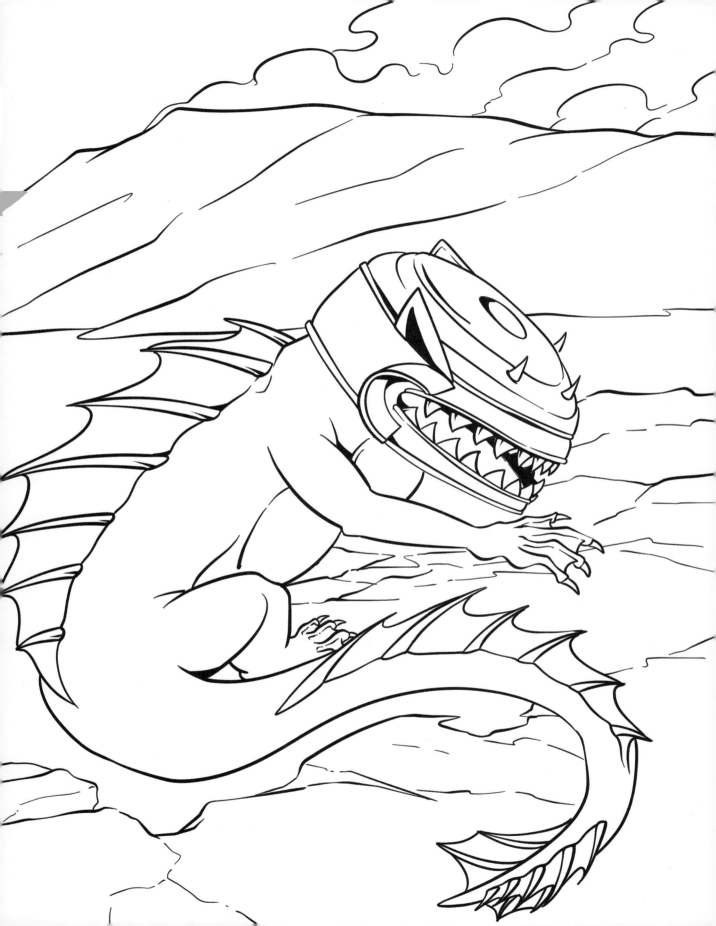

SUZUHIKO HIME すずひこひめ

Another notable tsukumogami, suzuhiko hime are the spirits that inhabit the kagurasuzu, or the chimes used in Shinto rituals. They are the bell princesses, and they dance about wildly and joyfully, mimicking the movement of bells when they ring. They don beautiful ancient robes and have the head of a bell. Delightful creatures, they calm the human soul, spark jubilation, and inspire both liberating dance and mannerly reverence. They are so beautiful that even the gods succumb to their charms.

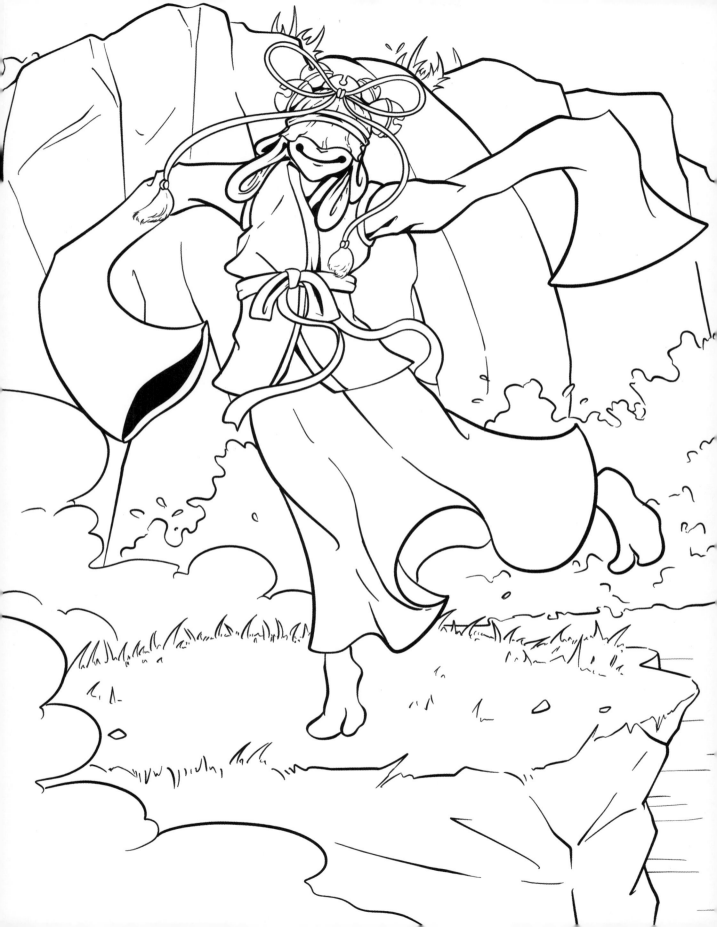

FURARIBI ふらりび

With the body of a bird and an almost doggish face, furaribi are small, flying creatures surrounded by a ring of fire. They haunt riverbanks, floating aimlessly as if searching for a home. They are born from the souls of those who have died but not yet passed on to the next life. These lonely wanderers are rather benign and will more often evoke pity than terror.

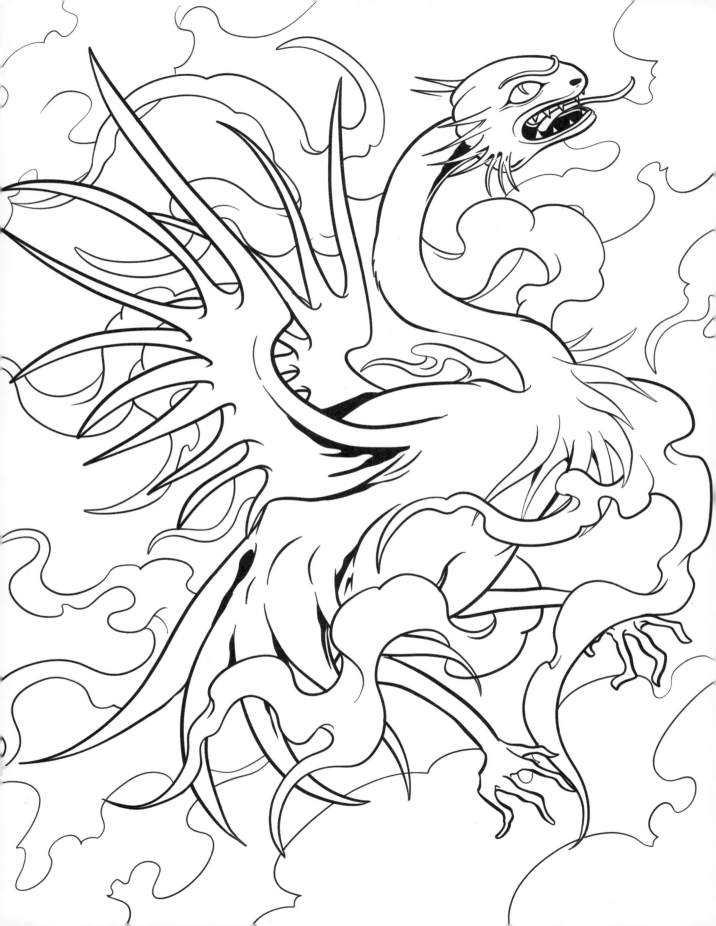

HAINU はいぬ

Soaring high above the forests, plains, and cities of Japan are hainu, or winged dogs. Vicious, ferocious, and typically dangerous, hainu are to be avoided by humans in the same way one might steer clear of a wolf. While not usually friendly, there have been times when a hainu has been said to be a loyal companion, similar to a pet. They are insatiably carnivorous, but are more likely to attack livestock than people.

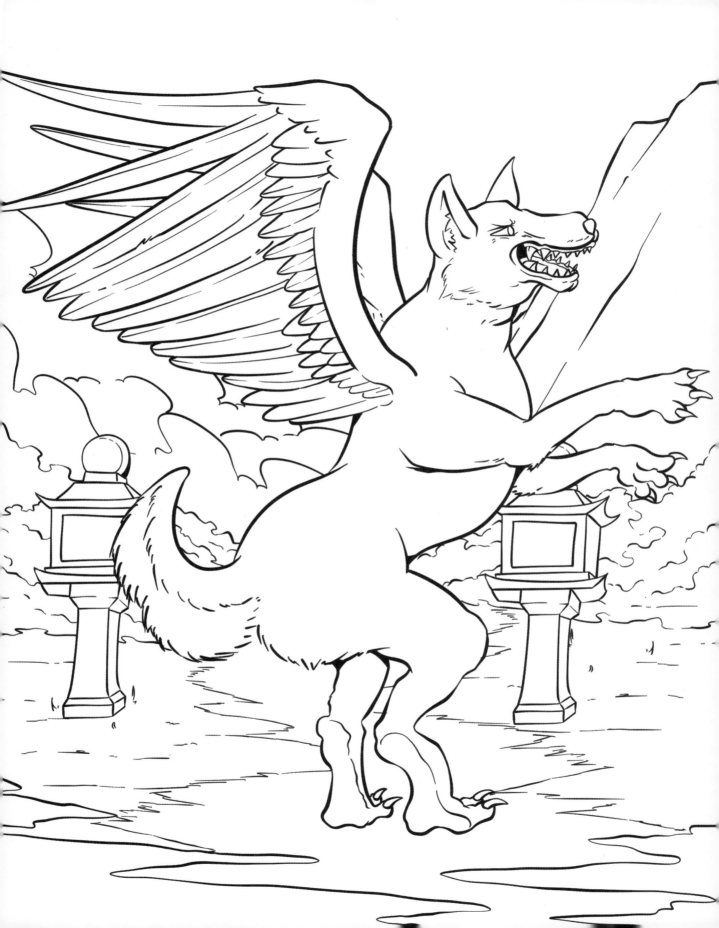

NARIGAMA なりがま

Living in ancient Japanese kitchens are the tsukumogami of kama, or iron cauldrons of old, otherwise known as narigama. With long arms and legs and a flaming kettle for a head (or for a helmet), these hairy creatures are powerful soothsayers who can predict the future. Simply place them over a fire, as you would make tea, then take note of the sound it emits, which indicates the answer to your mystical question.

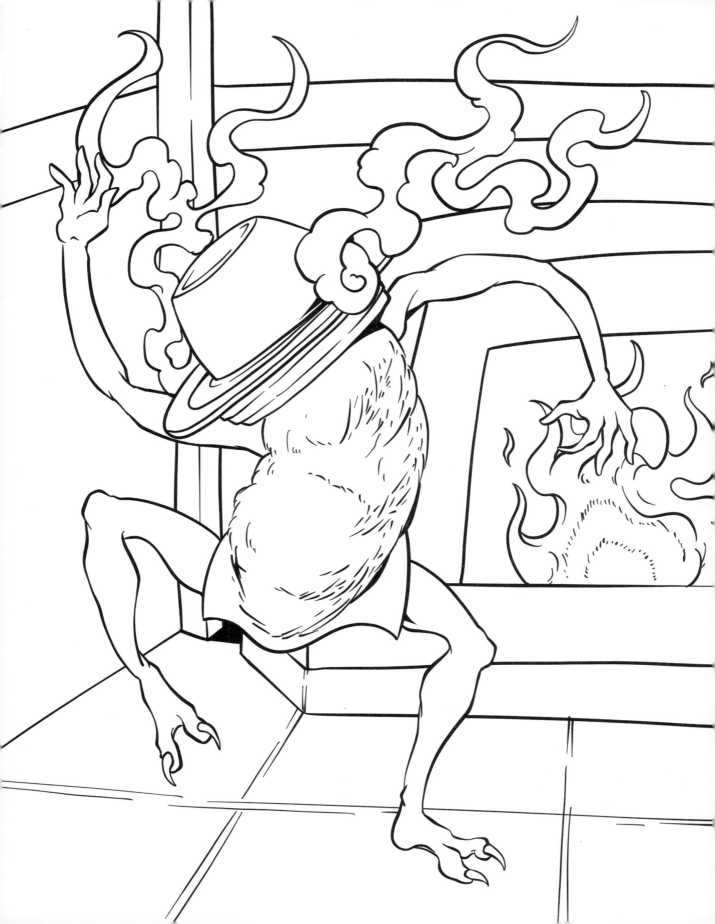

RINGO NO KAI りんごのかい

Although they might look like humans, ringo no kai are the spirits of apples that have clung to the branch for too long, left rotting and uneaten. Peculiar creatures, they will appear knocking at the door with their bulbous, apple-shaped heads and insist that the residents feed them their feces. They will gorge themselves on human waste while exclaiming what a delicious feast it is. Generous by nature, they will then insist the homeowners partake of their excrement in return.

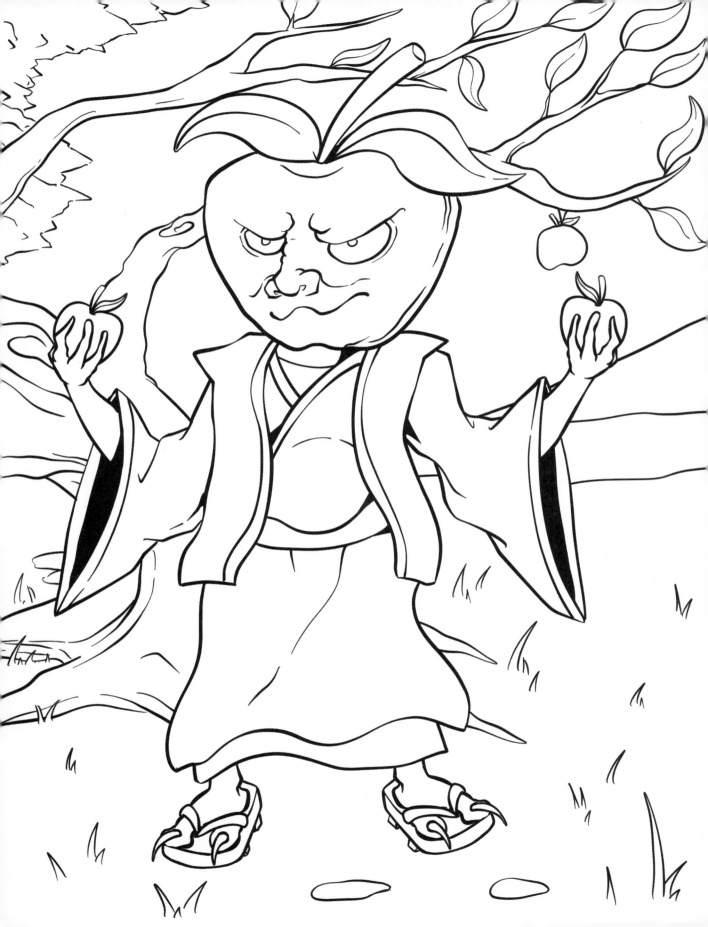

SHUNOBON しゅのぼん

Terrifying and ferocious demons, shunobon have needles for hair, razors for teeth, bright-red skin, and a single lightning-bright eye (although two-eyed varieties have also been spotted). Don't be fooled by their priestly robes: kind and gentle they are not. They love to scare humans by revealing their terrifying grins and gnashing their fangs, a sound described as a crack of thunder. Those who encounter them usually either faint or die from fright.

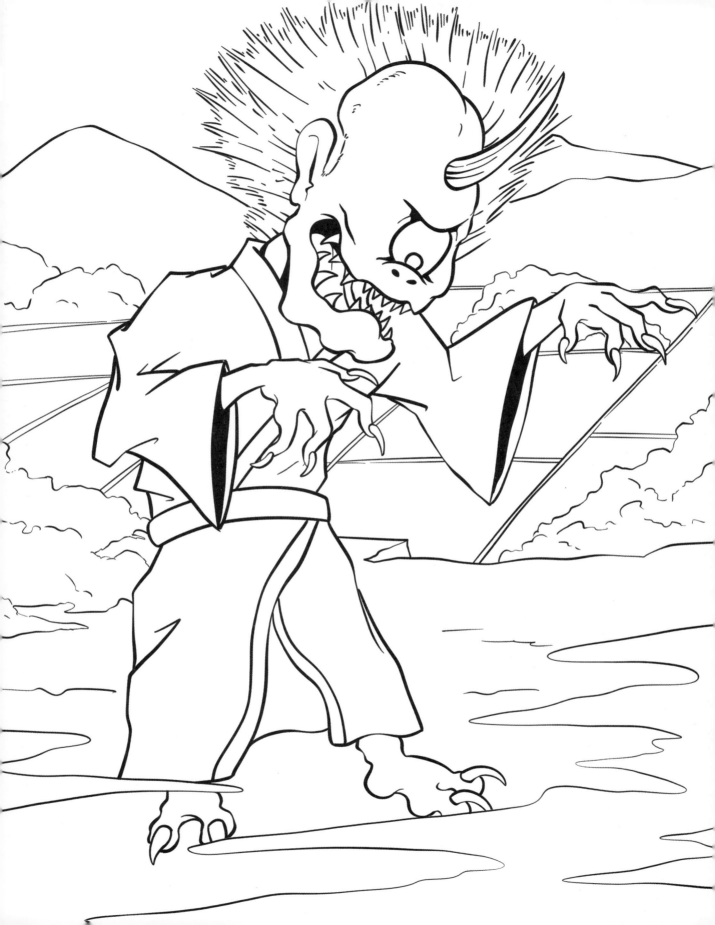

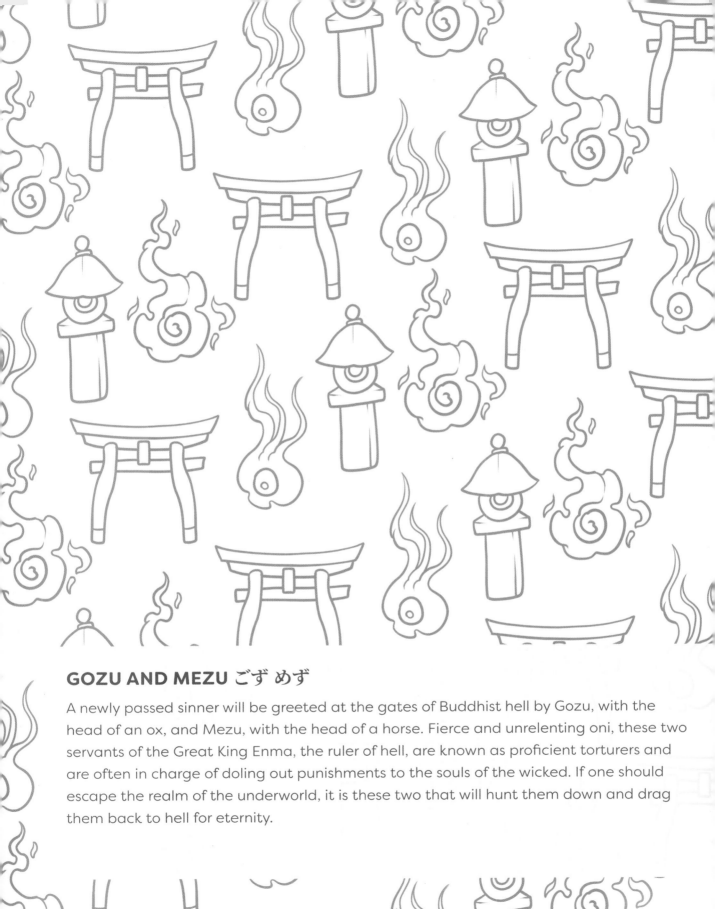

GOZU AND MEZU ごず めず

A newly passed sinner will be greeted at the gates of Buddhist hell by Gozu, with the head of an ox, and Mezu, with the head of a horse. Fierce and unrelenting oni, these two servants of the Great King Enma, the ruler of hell, are known as proficient torturers and are often in charge of doling out punishments to the souls of the wicked. If one should escape the realm of the underworld, it is these two that will hunt them down and drag them back to hell for eternity.

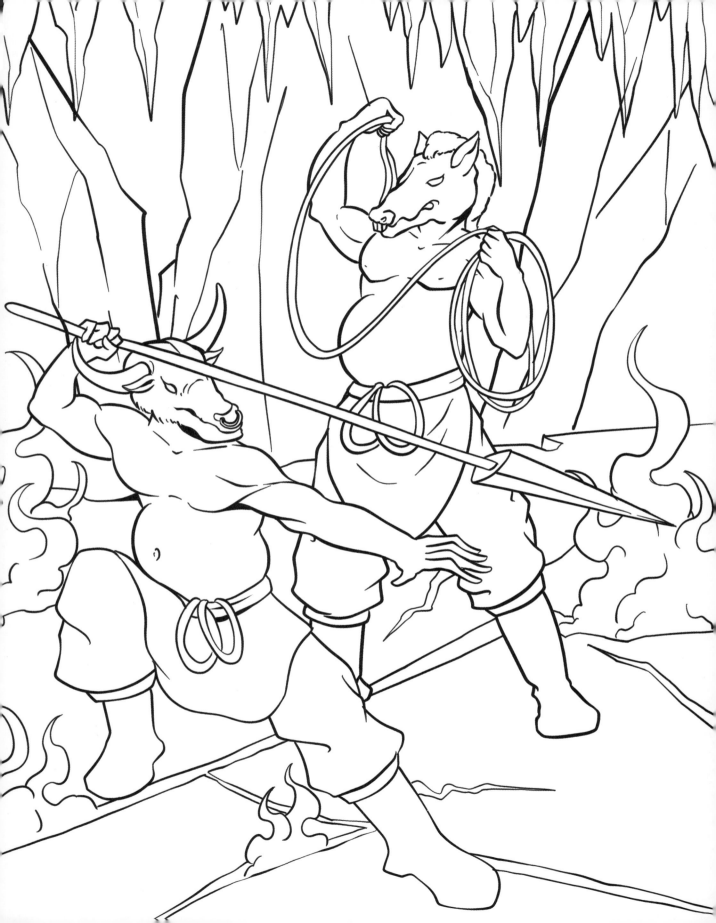

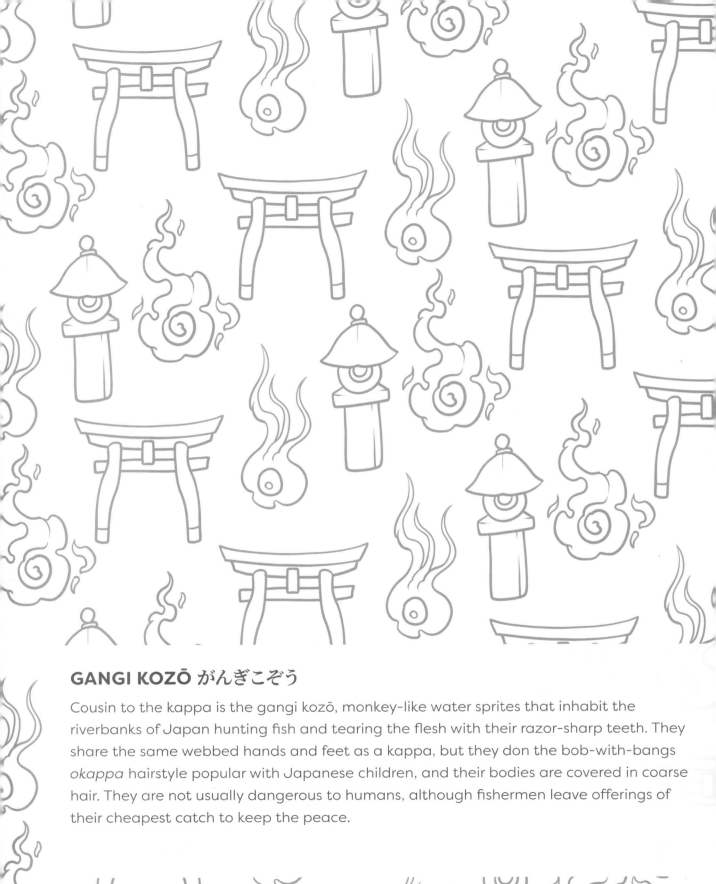

GANGI KOZŌ がんぎこぞう

Cousin to the kappa is the gangi kozō, monkey-like water sprites that inhabit the riverbanks of Japan hunting fish and tearing the flesh with their razor-sharp teeth. They share the same webbed hands and feet as a kappa, but they don the bob-with-bangs *okappa* hairstyle popular with Japanese children, and their bodies are covered in coarse hair. They are not usually dangerous to humans, although fishermen leave offerings of their cheapest catch to keep the peace.

ITSUMADE いつまで

Translated to mean "until when," itsumade are *kaichō*, meaning strange birds. With the face of a human, the sharp beak of a bird, the body of a snake, and the wings and talons of an eagle, they soar in circles, much like vultures, crying out like the tortured souls of the dead. They fly over areas where suffering and death are rampant, especially if there is nothing being done to alleviate the pain. Strange birds, indeed.

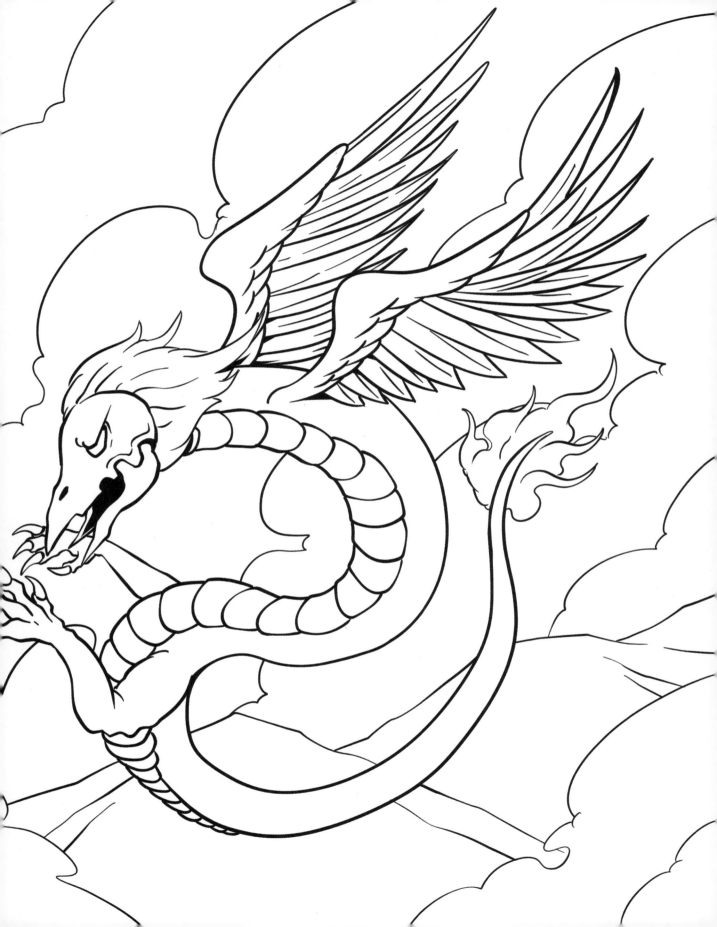

First published in 2024 by Wellfleet Press,
an imprint of The Quarto Group,
142 West 36th Street, 4th Floor,
New York, NY 10018, USA
(212) 779-4972
www.Quarto.com

Wellfleet Press titles are also available at discount for retail, wholesale, promotional, and bulk purchase. For details, contact the Special Sales Manager by email at specialsales@quarto.com or by mail at The Quarto Group, Attn: Special Sales Manager, 100 Cummings Center Suite 265D, Beverly, MA 01915 USA.

10 9 8 7 6 5 4 3 2 1

ISBN: 978-1-57715-466-2

Publisher: Rage Kindelsperger
Creative Director: Laura Drew
Editorial Director: Erin Canning
Managing Editor: Cara Donaldson
Editor: Sara Bonacum

Printed in China